HOLLYWOOD DADS

HOLLYWOOD DADS

PHOTOGRAPHS BY JOYCE OSTIN

Introduction by Paul Reiser

CHRONICLE BOOKS

SAN FRANCISCO

Library of Congress Cataloging-in-Publication Data:
Ostin, Joyce.
Hollywood dads / photographs by Joyce Ostin ; introduction by Paul Reiser.
p. cm.
ISBN-13: 978-0-8118-5837-3
ISBN-10: 0-8118-5837-5
1. Father and child—United States—Portraits.
2. Celebrities—United States—Portraits.
3. Ostin, Joyce.
I. Title.
TR681.F32O88 2007
779'.2092—dc22
2006027354

Manufactured in China.

Designed by Jeri Heiden and Sara Cumings, SMOG Design, Inc.

Distributed in Canada by Raincoast Books
9050 Shaughnessy Street
Vancouver, British Columbia V6P 6E5

10 9 8 7 6 5 4 3 2 1

Chronicle Books LLC
680 Second Street
San Francisco, California 94107

www.chroniclebooks.com

DEDICATION

To the Ostin Men:

Mo, you are an amazing man whose contribution to the world of music is unfathomable. Your loyalty, integrity, and sense of humor have made you the icon that you are today. Your beautiful family surrounds you always and looks to you for fatherly and grandfatherly advice. You are a father figure to many and an example to all. We love you.

Michael, you are my other half. I wouldn't be who I am today if it wasn't for you. Your true essence embodies both your father's music sense and your mother's soul, making you the talented and sensitive father and husband for whom I am so grateful.

Randy, what a brother-in-law! Keep us smiling, RanDooch!

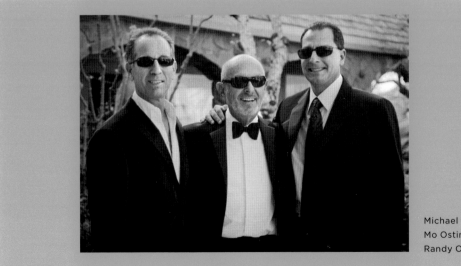

Michael Ostin,
Mo Ostin,
Randy Ostin

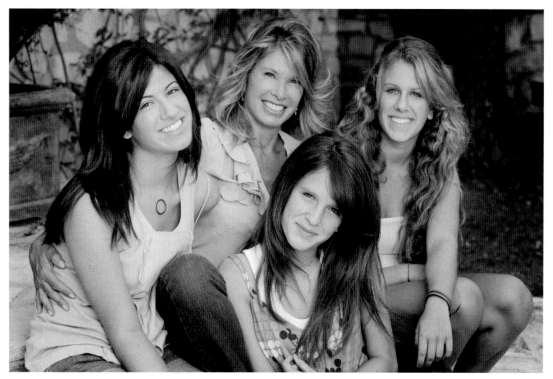

Anika Ostin, Joyce Ostin, Annabelle Ostin, Leyla Ostin

PREFACE

I never thought I could surpass the success of *Hollywood Moms*, but I have: I got fifty men to answer my call, which is quite a feat! The men in this book were so gracious, giving, and available. I am forever grateful to all of them.

Being a father is not an easy job. In fact, my husband, Michael, says it is much easier to go to work than it is to stay at home. Staying home, however, is not an option for him or for any of the hardworking men in this book.

Fathers have many roles to fulfill. I could probably think of thousands, too many to list. A father has to be the friend, the disciplinarian, the advisor, the fashion consultant, the driving-school teacher, the schlepper, the tour guide, the bartender, the banker, the listener, the calmer-downer, the chauffeur, the "bad guy," the guest-list advisor, the rental-ski carrier, the fire minder, the spider scooper, the tick remover, the burglar watcher, and the clicker controller. After attending to all of these duties, a father can relax . . . until the next emergency arises. His job is relentless.

Wives, children, grandchildren, godchildren—whatever the relationship may be—women are forever indebted to the fathers of the world. My father, grandfather, husband, and father-in-law have all made me who I am today: a very fortunate woman. I am incredibly thankful for all of the men in my life, particularly those who stood by me during the crucial time in which I battled breast cancer. I could not have done it without my loving husband by my side. I can only hope and wish the same for other women around the world. Men were put on this earth equally as great as women. Together, we can coexist in a loving, fun, spiritual joyride— if we allow each other the permission.

Like most five-year-old boys, my younger son jumps over, leaps off, or bangs into pretty much everything out there that can possibly be jumped, leaped, or banged. With the exception of having to eat a green vegetable, he's virtually fearless.

The other day, we were in the car, just the two of us, and I watched him in the rearview mirror as he gazed out at the world, lost in thought. He stared out the window, took a curious look at his arms, thought about something, looked back out the window, glanced down at his legs, and then, suddenly putting together for the first time the possible linkage between cause and effect, he said, "You know...I get hurt almost every day."

He wasn't complaining, he wasn't boasting. He was just having a moment of clarity. "Hmm...my shin is bruised from today, there's the cut on my knee from yesterday, this thing on my arm from Tuesday... Wow...Every day it's something."

And though I didn't say it, what I was thinking was, "Welcome to the world, buddy."

Not that I bang my knee every day. I don't. But I do believe that between waking up in the morning and going to sleep at night, there's a good chance something will happen that'll surprise me, and ultimately hurt me.

This phenomenon seems to be new. While, admittedly, I remember less and less of my life pre-children, I don't recall having this before them. I'm pretty sure it's only since becoming a father that I've noticed these daily "pings" of hurt. It hurts me when my kids are hurt, and it hurts me when they narrowly miss being hurt. It hurts me when they're saddened, disappointed, frustrated, or frightened. I'm saddened when they discover something about life that I wish wasn't so. It hurts me when I see them not trusting or believing someone—yet, ironically, seeing them actually trusting and believing breaks my heart, too. It all hurts a little. And I don't know how to not feel these things. Apparently, being a father means you get pinged a hundred times a day.

On the other hand—and it's a huge, enormous hand—you're also going to get pings of unspeakable joy. Daily. Practically hourly. From the simplest things. Like, watching my boys sleep stuns me with happiness. Seeing them wake up—same thing. Watching them chew a cracker? Kills me. Getting to watch them grow day by day, molecule by molecule, I feel such profound gratitude, it just makes me want to— as Mel Brooks would say—"jump in the air and sing 'Sweet Sue.'"

But I've noticed that both categories—the "pings of pain" and the "pings of happiness"—cause me to make the same involuntary (and not particularly attractive) facial expression. It doesn't have a name, but you've seen it. If you've ever looked at your children and marveled at how what originally appeared on a sonogram, smaller than a quarter, now speaks English and can pour itself a glass of orange juice, you've probably even made the face yourself. It's somewhere between a smile and a grimace. A "smi-mace," if you will. Or, if you prefer, a "gr-mile." It's not a pretty face. Imagine holding a wedge of cheese so unreasonably pungent you can't unsquinch your face, but you also can't put it down. It makes the back of your eyeballs

twitch a little, and your head shake from side to side in sheer admiration of its potency. My wife tells me I make this face all the time. Like an old guy who hums without knowing it. Now she just walks by me and says, "You're doing it again."

"What?"

"The face."

"No, I'm not."

"You're not? Look at your face."

"So?"

"Stop."

"Why?"

"It's creepy. You're just staring at them."

"But it's not bad staring—it's good staring."

"I know, but just—"

"Alright."

And I stop. But my point is that that face, and that feeling—the powerful bittersweetness, the sense of wonderment running right alongside the equally powerful sense of just how precarious that wonderment is—I get that all the time. And before I had kids, I didn't. Which, I suppose, means that becoming a parent has made me feel more "alive."

Now, trust me, that's not something I ever imagined saying. I was never an "I can't wait to have children" kind of guy. The reason we had kids was because…well, that's just what you do, isn't it? You "get married and have children." Because if you don't, everybody in the world nags you and pecks at you till you break down and say, "Fine, alright, we'll have children!"

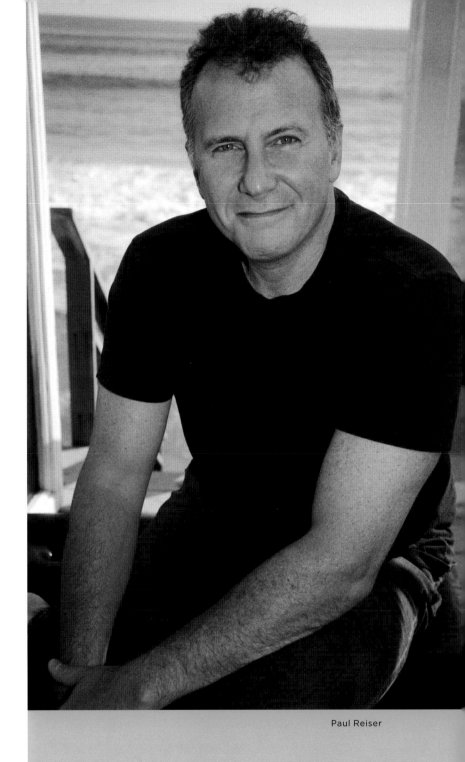

Paul Reiser

At least that was my journey. My wife, on the other hand, originally wanted children, I maintain, mainly so she could buy them clothes. She couldn't wait to buy tiny sweaters and pajamas the size of hand puppets. We briefly discussed getting a circus chimp, seeing how cute they look in those little suits, and how entertaining they'd be at parties. Plus, by having fuzzy animals instead of children, you cut out the whole "private school versus public school" discussion. Just leave 'em in the yard and keep tossing those bananas. But ultimately we decided against it and instead made two little boys, and I have to say it's worked out much better.

Originally, I thought it was nuts that anyone would even let me be a father. My understanding was that fathers, traditionally, had to be older. You know, like my father's age. Well, as fate would have it, when our first son was born, I was the exact same age my father was when I was born. That threw me. I started rethinking my image of my dad and had to entertain the notion that as much as I liked to believe otherwise, my father was probably not born a father. There was a good chance he started out as a kid, then spent a few years as a teenager, a single guy, newly-married guy...all the things that I myself had been. After the initial shock, I found this very liberating. I thought, "Wow, he probably didn't know what he was doing either. So how hard could this be?"

Now I can't believe how much I love being a father. Just hearing a sentence coming my way that begins with the word "Daddy" gets me every time. Even if what follows is unpleasant, as in "Daddy, I'm begging you—please stop singing." Or, "Daddy, I found this in my pants." I think, more than the sound of the word, it's the lingering, vague hint of a question mark before the sentence continues that I love, as in, "Daddy...?" There's such hope in the air there. Because as far as they know, I've always been a father. So when they say, "Daddy...?" the implication is, "Daddy...? You'll know the answer to this." Which is ironic, because in fact, I don't know the answer to anything.

Yeah, I know how to have lots of love and lots of patience. Everything else? Not so much. There's just a lot of stuff I'm not up-to-date on. Like, for example, I don't know what to do if anything happens. If nothing happens, I'm fine. But the possibility of something happening makes me very nervous.

Also, I don't know where anything is. In my own house, or, for that matter, in the world. I just haven't really been paying enough attention. I sometimes say Argentina when I mean Venezuela, I don't know why TiVo works sometimes, but sometimes it doesn't. I don't know where anyone in my family might have left whatever it is they're looking for. And—probably more important than anything else—I'm not always clear on what my wife has already said to the kids. This is key. It's imperative to know what conversations have already been had, what assurances have been made, and what ground rules have been laid. Otherwise, you're dead.

My kids not only know they can manipulate me, they taunt me with the fact that they know it, and that, furthermore, there's nothing I can do about it. Recently, I said "yes" to something I probably should have said "no" to, and my older son, with his best "look how I can be cutesy like Shirley Temple even though I'm a boy and also I don't know who she is" face, looked right at me and said, "Oh, thanks, Daddy.

You're the bestest Daddy in the whole wide world."

"Oh, really?" I said. "How come?"

"Because you let me do anything I want, all the time, even though you're not supposed to."

I think what I said was, "Why, thank you!"

I'm not entirely a pushover. I do have a few tricks. For example, I've learned that the key to effective discipline with children is to identify what's most important to them, what gives them the most pleasure, and then *take it away*. Or, more likely, threaten to take it away. In our house, the luxuries most frequently put in jeopardy are TV time, dessert, and the chance to continue to live with us. Usually, I start with TV.

"Okay, if I hear the word 'butt-face' one more time, you're losing TV tonight." That gets their attention. But invariably, within minutes, I'll hear something to the effect of "Blah blah blah blah butt-face." "Okay, buddy, you just lost TV tonight, and one more time, you're losing tomorrow, too."

Then you just keep raising the stakes—a week, a month, and so on. There is a point, though, at which they're reasonably sure you can't back up the threat.

"Okay, you are now not allowed to look at a TV, computer screen, video phone, or any broadcast media till you're fifty-five, or until seven years following my own death, whichever comes later. And don't think I won't know, because I will."

Of course, the threat of taking things away doesn't work if they don't like anything. They've got to really like something—otherwise you've got no cards to play. It's like those old prisoner-of-war movies where everyone barters for cigarettes. I always wondered about the one guy who doesn't smoke. How're you going to control him? You can't take away his cigarettes, because he doesn't have any. And you can't bribe him with the promise of more cigarettes, because he doesn't want any. The whole system breaks down, and the guy would be unstoppable. So before you try the tough-guy routine, make sure your kid likes something.

Though sometimes, it's tricky discerning exactly what it is they want and don't want. A few weeks ago we were all at the dinner table and my ten-year-old was doing a great impression of a really obnoxious ten-year-old who was raised by terrible parents. With great conviction I said, "Okay, you know what? You're going to leave the table right now!" There was an awkward silence as my two sons and their mother all turned and looked at me with a palpable pity, till the little brother complained.

"But he wants to leave the table. That can't be the punishment— 'cause then he wins."

I didn't miss a beat.

"Oh, you want to leave the table? Then, you can't!"

"Till when?"

"Till I say so. And we're taking your plate away so you will not have the rest of your dinner."

"I don't want the rest of my dinner."

"Then you have to eat it! Wait a second—which is the thing you don't want?"

"He wants to be done with dinner so he can go play."

"Alright, then—the exact opposite is what it shall be. More food, and no playing."

Then I saw him smile to himself, which made me suspicious.

So I went the other way.

"Wait a second. I wasn't born yesterday. You wanted me to say that, didn't you? You were trying to trick me. Okay, wise guy. Now I decree it shall be the opposite of what I just said was going to be the opposite; now you must leave the table and go play at once! And that is final!"

The truth is, disciplining will never be my strong suit because, secretly, I'm always kinda rooting for my kids to win. I mean, I remember what it's like to be a kid, how good it felt to win, to get one over on your parents. So who am I to deny my own children that sense of victory?

I remember once, as a kid, I did some dumb thing or another—I forget exactly what. I think I may have shot a convenience store clerk in Reno. Oh, no, wait, that wasn't me—that was Johnny Cash. Okay, scratch that. I think my actual crime was I lied about where my friends and I were going one night. My father—because he wasn't born yesterday, either—called me on it, and I felt appropriately stupid and embarrassed. And then in a rare moment of parental candor, my father lovingly showed his cards and explained, "It's okay. *Your* job is to try to get away with stuff. And *my* job is to try and stop you. That's how the game works."

And it is a game. A really *fast* game, too. I mean, not to get all "Sunrise, Sunset"-y here, but no kidding—it really does go unbelievably fast. And you'd think knowing that in advance helps, but it doesn't. Everything—the good stuff, the bad stuff, the hard stuff—it all ultimately goes away. It evaporates, with no clear warning. One day you just notice, "Hey, you stopped doing that thing where you drop your shorts and sit on your brother's head. I guess we've moved on. Good." But the things you like fly away, too. "Hey, you stopped

asking me to read you bedtime books. Hmm...I guess that's over." Or, "Hey, you don't waddle when you run anymore—you run like a big kid now. When did that happen?" The changes are so imperceptible. But, I suppose, how else could it be? Your kids are never going to tell you in advance, "You know how I can't get off the sofa without jumping over the coffee table and banging my knee every time? I'll be outgrowing that next month. And also, the fascination with boogers? End of July—done." It never works like that. Nowhere along the growth curve do kids announce, "Dad, Mom, y'see this little fleshy part of my thigh that's soft and still somewhat toddler-esque? Well, take a good look, because that's all changing. Wednesday at three." No one tells you that, but come Wednesday, sure enough, it's gone.

So, as it turns out, my father did know what he was doing. His game plan was simple, but on-the-money. "*You* be the best kid you can be, *I'll* be the best father I can be, and let's see what happens." And "what happens" is ping, ping, ping, ping, ping! Front seat, back seat—makes no difference. Every day it's something. Nobody leaves here un-pinged. But in the end, they're all good pings. And when you realize that anything and everything could be gone by Wednesday, all you can do, I've decided, is to really try to pay attention Tuesday.

THOUGHTS ON FATHERHOOD

Below are the three questions I asked each father to consider as he posed with his children. Their answers run the gamut from hilarious to heartwarming. —*Joyce*

What are your tips on being a father?

What has being a father been like for you?

What was your relationship with your father like?

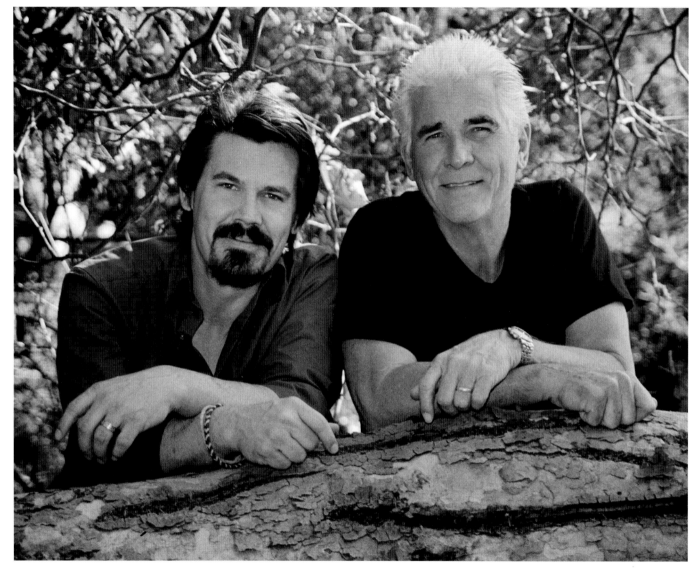

Josh Brolin, James Brolin

James and Josh are quite the *GQ* cover. Josh had a sense of humor, via e-mail, that totally stumped my assistant Caryn and me. We both felt so stupid. Once we figured it out, I knew what to expect. They both have an amazing sense of humor along with a spiritual side. Together they made my job an easy one as they are such an incredible father and son duo. —*Joyce*

JAMES AND JOSH BROLIN

There is no manual.
Every day of being a parent
is a constant improvisation.

You can be confronted with the same problem you had yesterday, and there is no way to deal with it the same way given that your child and you have changed drastically in the past 24 hours. As a parent I've always seen my job as a religion to be challenged. Our children try and crack us (their mother and me) to see if we are as safe as we say we are. I believe it is a test in security: "Will you really be there for me when I need you?" kind of thing, and the rest of the time is riding the Zipper at the local carnival of parenting—round and round, dizzy as she goes. There is nothing more fun, and nothing more uncertain. —*Josh*

My son has been a better father to me than I have been to him. Thank you for all the lessons in life, my son. I am a better man because of you.

Here are points of view and advice from a father who's constantly learning from his children:

When a father asks "do I look stupid?" never answer.

When caught with the cat's tail in your hand, always demonstrate that it is the cat that's pulling, not you.

My grandfather years ago taught me two very wise and comforting facts that I pass on to all you children:
• Real estate was always priced too high. But it will never be too late to buy again and again. The second was about fear and courage:
• You will always hear that the world is coming to an end soon, yet the day will never arrive.

Fatherhood can make a man grow up right before your eyes.

Truly the best thing that ever happened to me. And in the most perfect, most interesting time in history, And in the most perfect place on earth. I'm one lucky man.

I'm a father. —*James*

DAVID DUCHOVNY

Have patience. Becoming a father opens up depths of feeling you never knew existed. Being a father has brought me to a better understanding of my own father— it goes round and round.

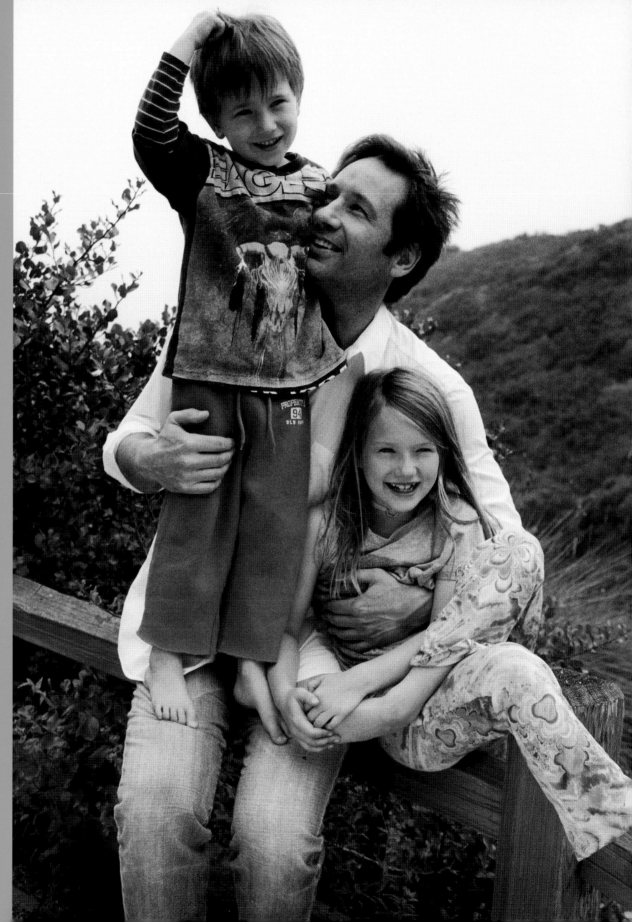

Kyd Miller Duchovny,
David Duchovny,
Madeleine West Duchovny

David is truly a family man.
His life with his wife, Téa, and their
children seems so loving and content.
I had shot Téa and Madeleine West
for *Hollywood Moms*, so I was excited
to see how much she had grown.
Both children showed their love for
their daddy. They couldn't stop
hugging and playing with David. I saw
seriousness in David's eyes that made
him all the more intriguing as a
father, as well as an actor. —*Joyce*

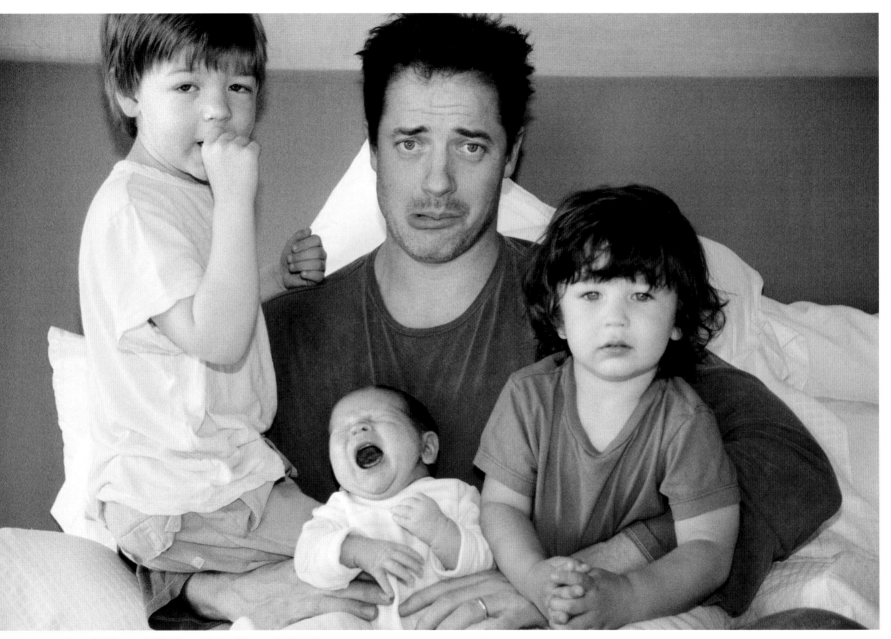

Brendan Fraser, Griffin Fraser, Leland Fraser, Holden Fraser

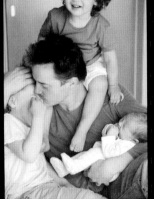
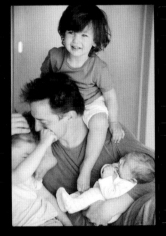
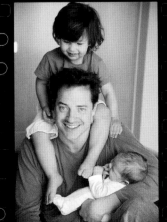

BRENDAN FRASER

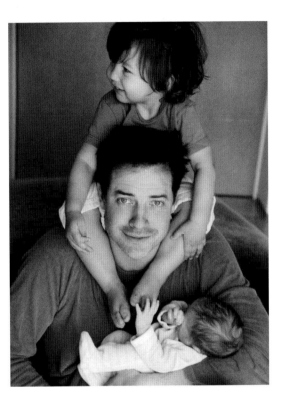

What a cool dad. What a family!
He sat there the whole time with
a sense of humor and comfort
in his role as a father. The kids
were climbing all over him (except
for Leland the two-week-old!),
and he just flowed with it all. He
looked as though he was meant to
play this role. An incredible actor,
father, and husband. —*Joyce*

MICHAEL CHIKLIS

Listen to them,
talk to them,
and most of all,
love them
every minute.

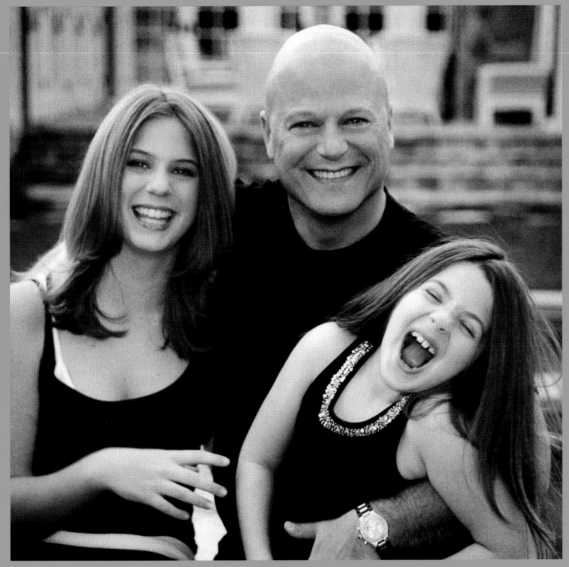

Odessa Chiklis, Michael Chiklis, Autumn Chiklis

With all of the intense characters that Michael has played as an actor, I found his smile softened his piercing eyes. Michael's humor lends itself to the ease he had with his daughters. His girls are adorable and they clearly have fun with their daddy, no matter what role he plays. —*Joyce*

TOM HANKS

There is only one real tip for fathers—
try to tell your kids the truth, but only when
they can handle it.

Fatherhood is better than TV. You never get
bored, you are constantly entertained, and the
program changes every 15 minutes.

My dad is a comfortable mystery to me.
I know I can ask him any questions about
his life and experience and he will casually
mention hair-raising experiences he went
through that produced the calm and
peaceful man I call Dad.

I waited for this photo for about
9 months. I knew that Tom wanted to
do the book but because he was so busy
finishing *The Da Vinci Code*, I had to
wait. When Tom became available,
I was out of town and missed a few of
his calls. He left me messages asking
when we could shoot. Can you imagine:
Tom Hanks behind the blinking light
on your answering machine?! Finally,
we got Tom together with his father-in-
law, Al, and his oldest son, Colin. I felt
such a heartfelt relationship between
Al and Tom to which I could totally
relate as I had that relationship with
my mother-in-law, Evelyn. —*Joyce*

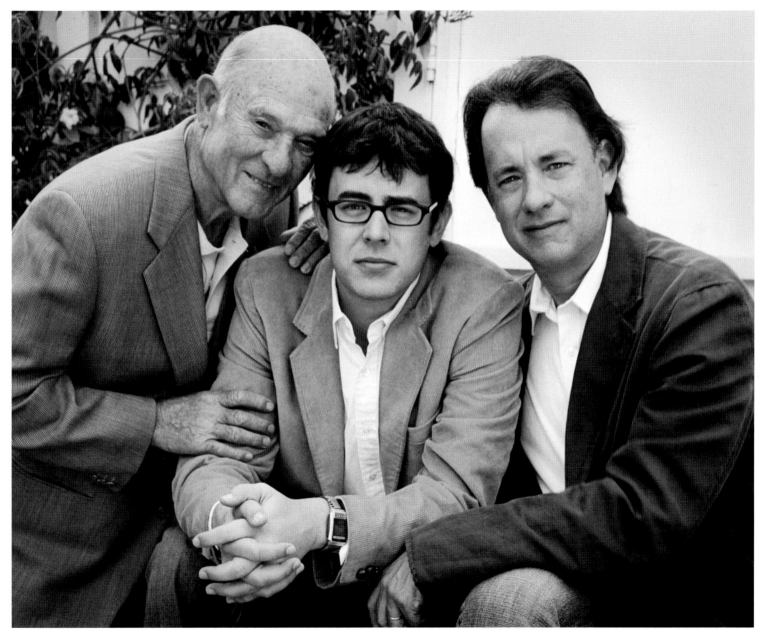

Al Wilson, Colin Hanks, Tom Hanks

LIONEL RICHIE

Every time I have had the pleasure to interact with Lionel, he has been the most gracious gentleman. His smile and voice are sure to put anyone at ease. His gentle way is the "Lionel style." His talent has never gotten in his way of being a loving, sweet man and a caring father. He has blessed us all with so many memorable songs. We will never stop singing for years to come. —*Joyce*

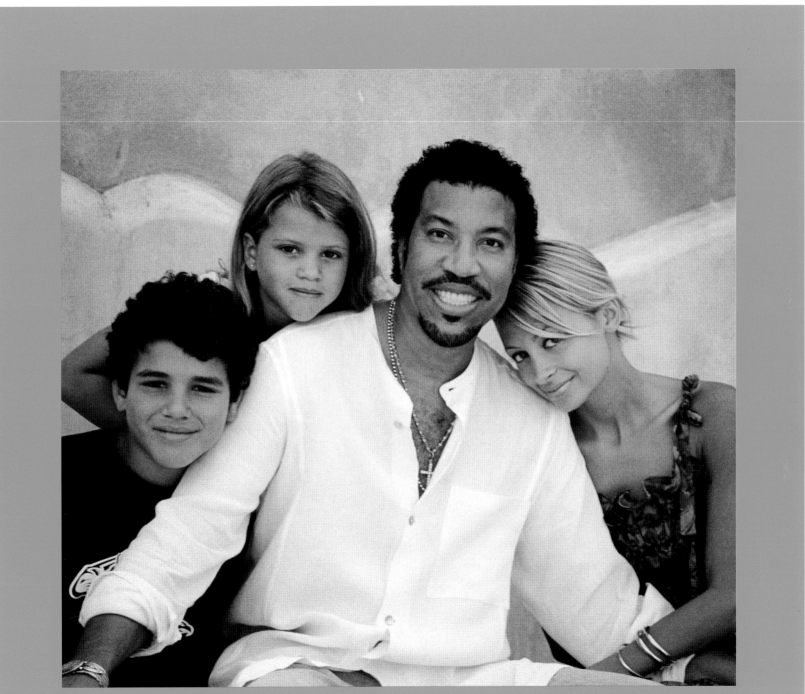

Miles Richie, Sofia Richie, Lionel Richie, Nicole Richie

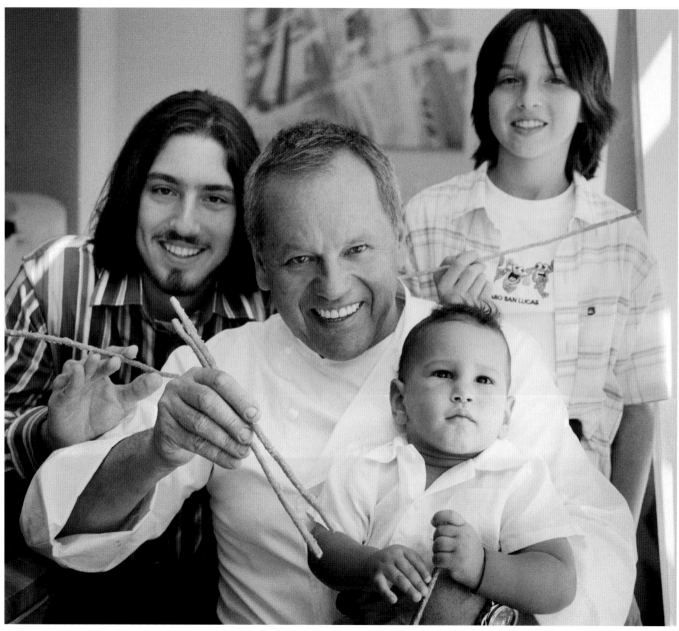

Cameron Puck, Wolfgang Puck, Oliver Puck, Byron Puck

WOLFGANG PUCK

The hardest part
about being a father
is the balancing act
of business and family—
spending quality time
with our children,
not just watching football
or basketball on TV.

It's the single most amazing experience for any man to see his son being born, then growing into a boy, and later becoming a man.

I left my home as a 14-year-old to begin my career, and I wish I could have had a better relationship with my father. But times were different then. I try every day to do a better job of being a father than the day before!

Wolf was his jovial self. He came into his new restaurant, CUT, dressed up like the chef that he is. His upbeat way and constant smile make him the chef to whom you can always ask any cooking question. Wolf's older boys, like any teenagers, would rather have been doing something else, yet they were very amenable while I took the photo. The baby, on the other hand, was just interested in eating his daddy's breadsticks. Thank you, Wolf, for all of the great food that you have cooked for the world! —*Joyce*

JOHN LEGUIZAMO

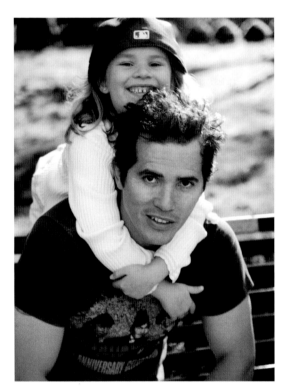

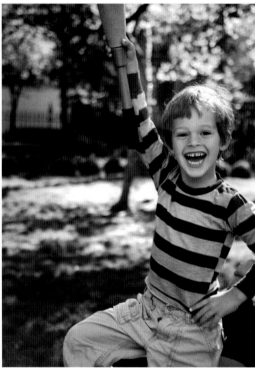

John, being the comedian that he is,
certainly kept his kids entertained...
or did they keep him entertained?
He was absolutely adorable and playful.
Being a young father, the energy was
high, and he was kept quite busy
with the ball and the bat in the park...
even though I had to duck from getting
hit by the ball. Needless to say, I had
to work quickly. —*Joyce*

I try to give my kids some of the values
my parents passed on to me, whether
they like them or not... Now I have my own
value system: 1. "Boring" is not allowed...
no such thing. 2. They have to earn material
things, i.e., toys, candy, allowance. 3. Laugh
tons with them... about anything and
especially about yourself.

The older I get the more I resemble my father,
not just in looks but in personality traits...
It must be some species punishment so that
you are reminded to honor your parents
through narcissism. I'm now turning lights off
everywhere, lowering the AC when no one
is looking, lowering the heat in the pool
when everyone is asleep. Tucking my shirts
in... yup, it's called recycling... I'm reusing
old habits to save the environment somehow.

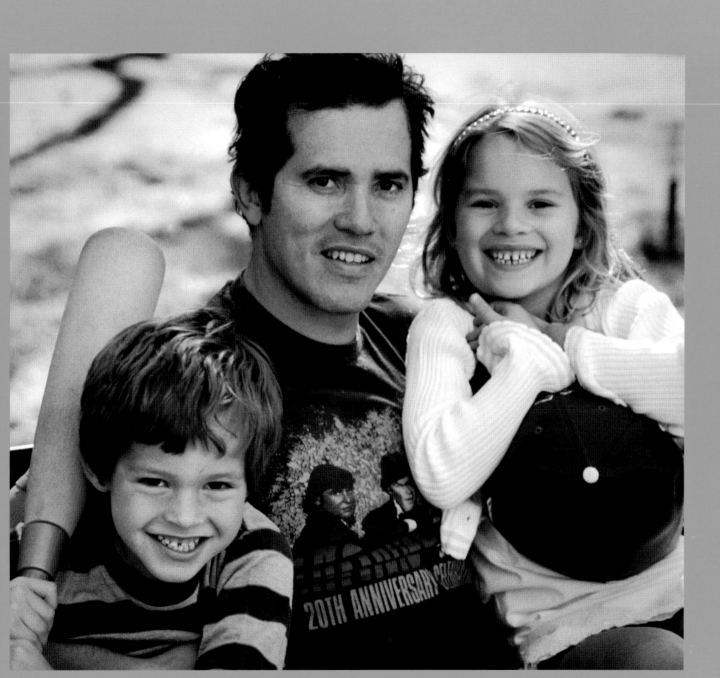

Lucas Leguizamo, John Leguizamo, Allegra Leguizamo

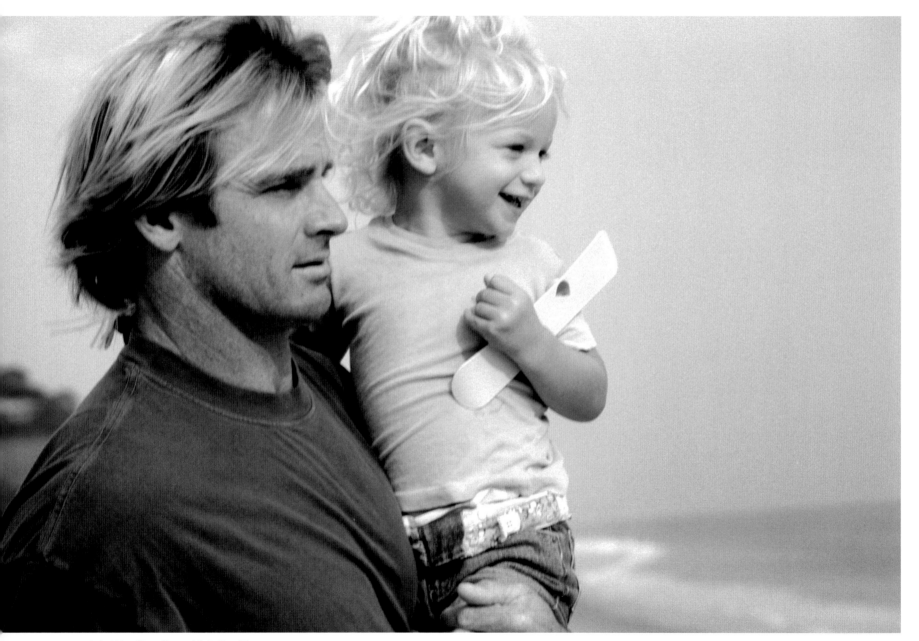

Laird Hamilton, Reece Viola Hamilton

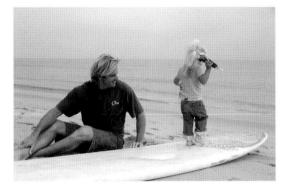

LAIRD HAMILTON

The most important thing that you can do is to give all your love and lots of time to your children.

Fathers should bring adventure and excitement while making their child feel secure. Give firm discipline, and you'll get far with discipline. Treat your child as an honored guest of your home. Give them grown-up answers to their questions. Try and exercise patience and tolerance like you never knew you had. And always remember that your children owe you nothing. You, on the other hand, owe them everything!

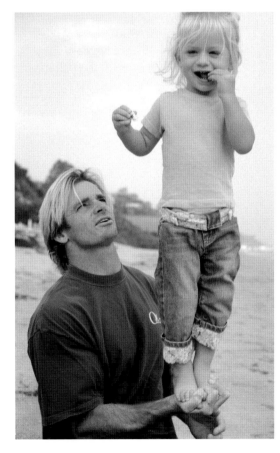

This shoot was really memorable to me. It was right after my mother-in-law, Evelyn, passed away. Laird was so spiritual and cosmic and open to listening to me talk about her. I knew this gorgeous, unbelievable athlete was truly a star with a huge heart. When he put his little daughter in his hands, the look of love and fun he was having was striking. I thank him for being so open to me at such a vulnerable time in my life. —*Joyce*

ROBIN WILLIAMS

When I showed up Sunday morning in Northern California after a long night in Los Angeles, I was laughing and in the "Robin Williams mode." Having a good time and laughing seem to be the norm in this family. When Robin opened the door, the first thing I saw on his T-shirt was the statement, "Photography is not permitted." How apropos. I knew the shoot was going to go well. His children were great and so were the dogs! Robin, bring on the laughs! —*Joyce*

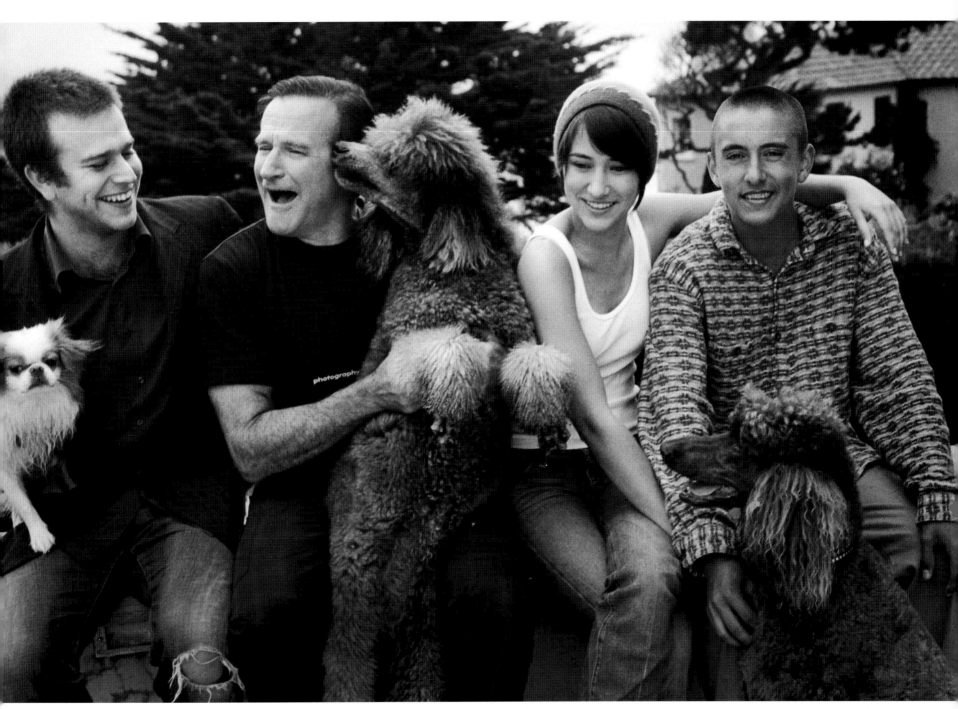

Louie (Chin), Zak Williams, Robin Williams, Mizu (poodle), Zelda Williams, Cody Williams, Kiwi (poodle)

BRUCE WILLIS
ASHTON KUTCHER

"Just because" and
"because I said so" are
not suitable answers.
There is no replacement
for love and affection.

If I had listened more to my father then,
I'd have a lot fewer questions now. —*Ashton*

Scout Willis,
Ashton Kutcher,
Tallulah Willis,
Bruce Willis,
Rumer Willis

Thanks to Demi, this shoot happened.
As she pointed out to me, the
message in this photograph is a very
important one. The more love you give
children, the better. Even though
their family may not be a traditional
one, there is certainly not a lack of
parenting or love. Oftentimes when
there is a step-parent, the family
becomes a closer unit, with more love to
go around. This was certainly the case
when I shot this picture. The fun,
love, and respect that I felt here were
something to be treasured and a
lesson to be learned. —*Joyce*

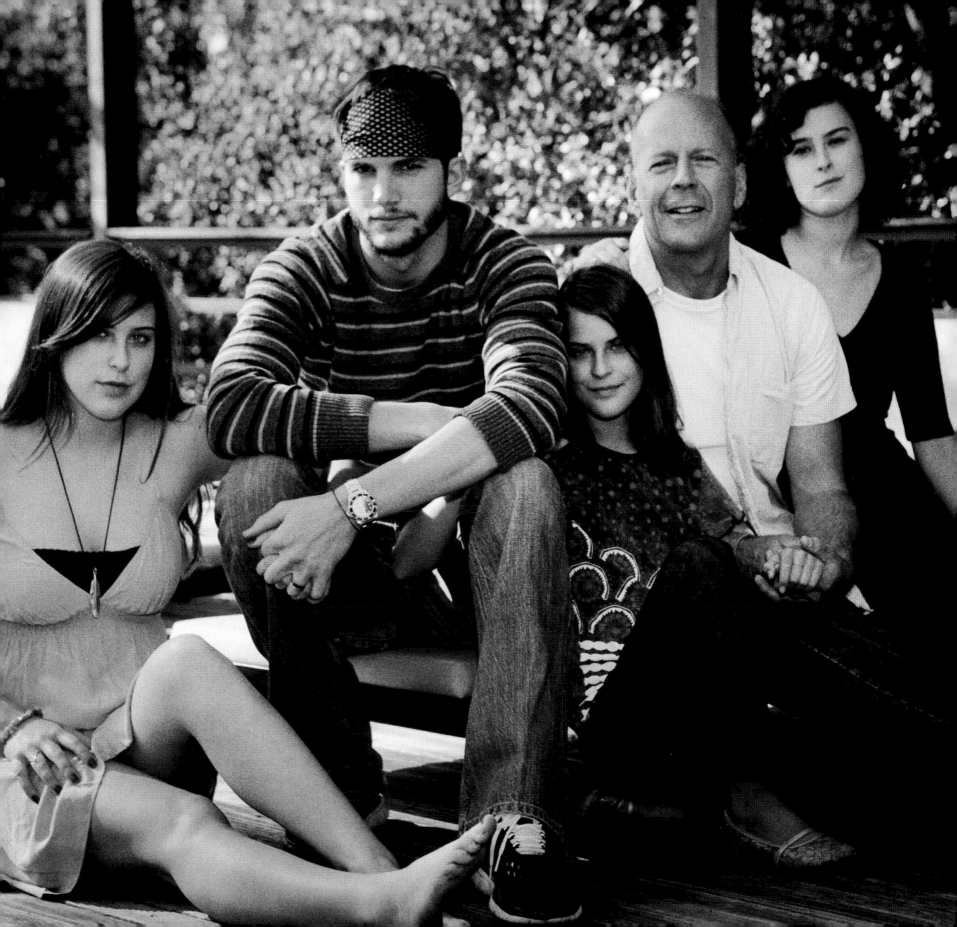

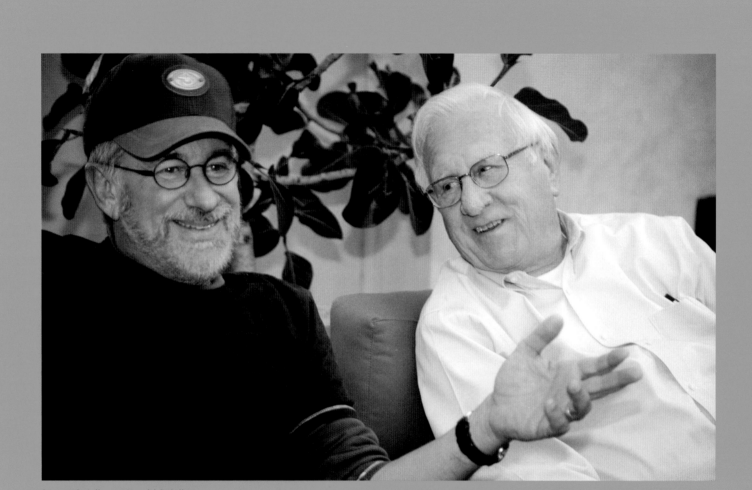

Steven Spielberg, Arnold Spielberg

STEVEN SPIELBERG

(with his dad, Arnold Spielberg)

I work very hard to make my kids understand that they take precedence over everything else that happens in my very busy life. I also try to say yes as often as possible.

My father is a neat guy. He's also the smartest man I know and I still listen with every fiber of my being to all of his sage advice. —*Steven*

As a father you do your best to inculcate your children with the values you cherish: fairness and freedom to think and explore. Steven exemplifies my fondest hopes and expectations. I see in him the wonderful combination of a genius in his field, a loving father to his children, a great husband, and a concerned and philanthropic citizen. Can you imagine that I once wanted him to be a successful electronics engineer! —*Arnold*

Steven is a dear friend of mine, but I wasn't sure that he was going to participate in my book. When he said yes, I was relieved that I wasn't putting him on the spot—and that I wasn't rejected! When I shot Steven and his dad, Arnold, they were so adorable, sweet, funny, and *hamisha*. Although he is so down-to-earth, I was still nervous to tell him what to do. How could I tell Steven Spielberg where to stand and how to look at me? This man is the biggest director ever to live, and I was telling him what to do. So, I actually let him tell me where he thought the lighting was best: in between the trees. It is always my greatest pleasure to be in his and his family's company. —*Joyce*

GABRIEL BYRNE

This photo was taken in Malibu on a Sunday afternoon while Gabriel and Romy were visiting. I think I had just started my book two weeks before, but Gabriel, being the great, easygoing guy that he is, was willing to be a part of it. He is so smart, clever, and handsome: a very alluring man. He, too, adores his children and is a great father. Sometimes perplexed as to what to do or say—as all fathers are— at the end of the day, he is always ready and willing. —*Joyce*

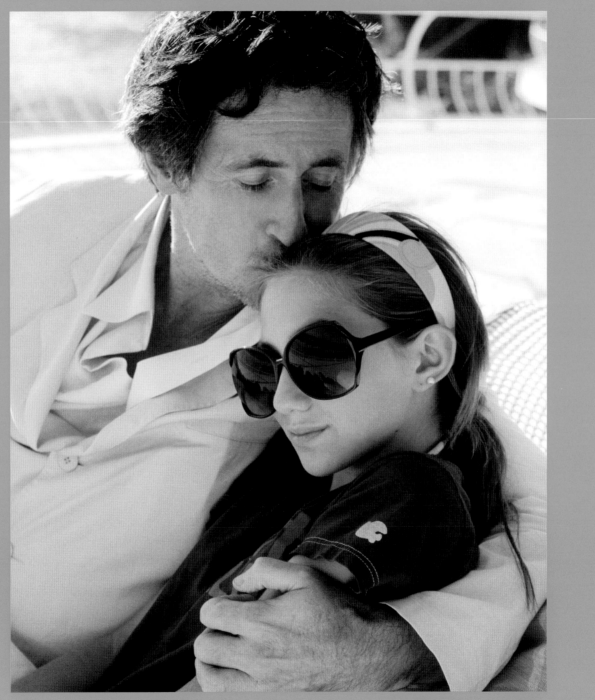

Gabriel Byrne, Romy Byrne

OZZY OSBOURNE

Parenting is the
hardest job in the world,
but also the most rewarding.

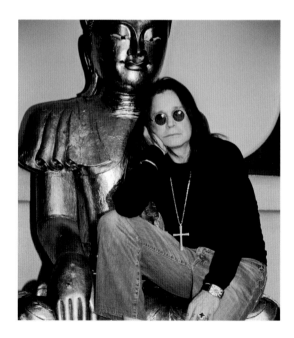

I arrived at the Osbournes' house and there was Ozzy ready to go. There really is a "reality" to the Osbournes; however, the reality is that of a talented, genuine family. The children, Kelly, Jack, and Aimee, really do treat their mom and dad with the utmost respect. I loved watching the closeness they all shared together. —*Joyce*

Jack Osbourne,
Ozzy Osbourne,
Kelly Osbourne

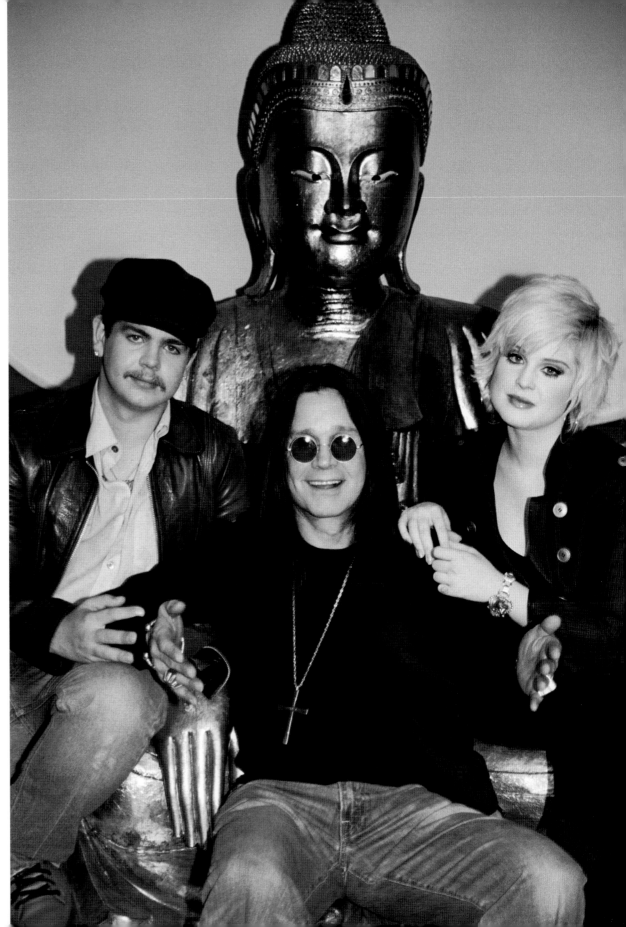

HENRY WINKLER

The three most important things you need
to know about being a father are: 1. It might
be one of the most difficult jobs on the face of
the earth. It might actually be more difficult
than climbing Mt. Everest without clothes or
oxygen. 2. To always remember that your job
is to repeat the same sentences eight times
a day for about 18 or 19 years. And, if you
internalize that thought, your child will have
a more difficult time making you nuts. 3. What
you put in is what you get out. Children see
your every nuance, your every move, your
every action, and hear your every word. So,
just remember to be aware that the whole of
you is being absorbed like a thirsty sponge
and the whole of you will be reflected in the
world's mirror without a doubt.

I think the most important single thought
about being a dad is that in structure comes
freedom. I really, really believe children feel
loved the most when they are surrounded
by your rational boundaries.

Henry is the quintessential father.
No matter how many kids are
around, his own and their friends,
Henry is at the center of it all. He is
caring and constantly wanting to
help in any way possible. You can
always count on Henry to make you
laugh, smile, and feel special. He is
truly a genuine man with a big heart,
always willing to give. —*Joyce*

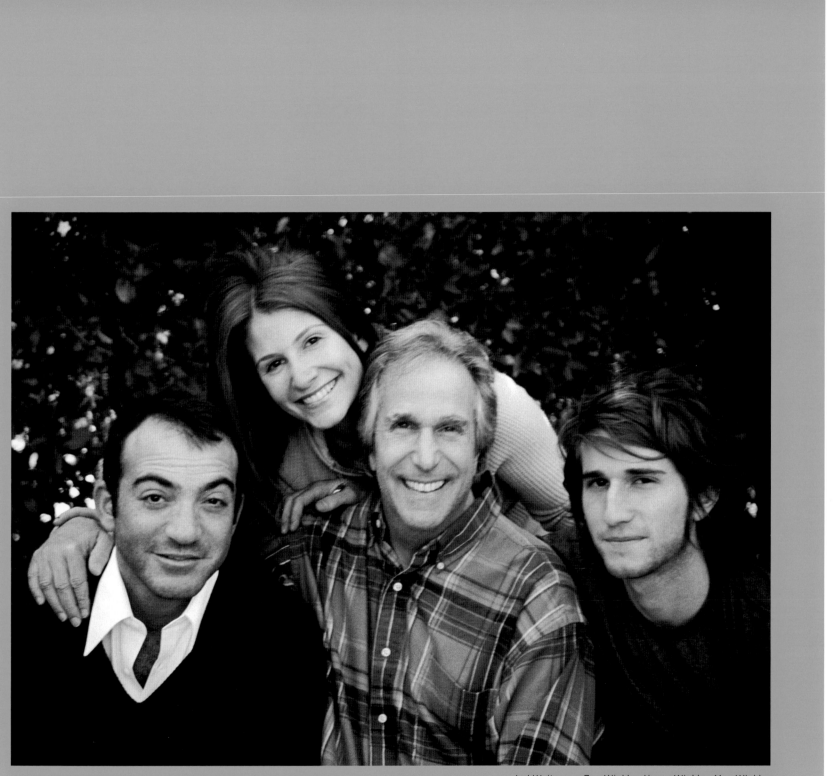

Jed Weitzman, Zoe Winkler, Henry Winkler, Max Winkler

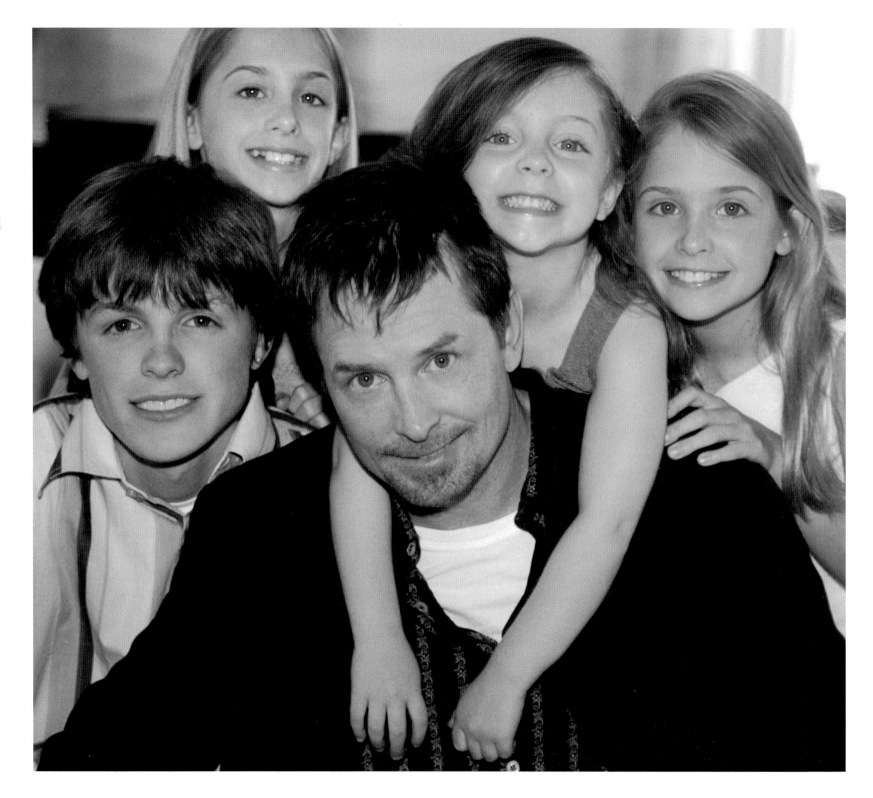

MICHAEL J. FOX

It would be easy to say something lofty and general like, "Always the loving response," but it's not always so easy to achieve that state of parental Zen. I guess the first piece of advice that comes to mind is a warning not to look at your kids as vessels through which to continue expressing yourself, your unfulfilled goals or worldview. Listen and they'll express who they are, whole new creatures, strange, mysterious, frustrating, maybe, but beyond your wildest projections. It's a ride you can't design, a trip you can't plan. Just hang on and enjoy.

My dad was an old-fashioned, school of hard knocks kind of guy. Grew up during the Depression, came of age during World War II, and then spent 25 years in the army. Really a different kind of father, and person, than me, tougher. But he was loyal and family-first and he'd walk through a firestorm for his kids. Even though he thought actors were hippies, and show business was another planet, he drove me to L.A. from Canada to find me an agent because that's who I was and what I wanted. I miss him.

Sam Fox,
Aquinnah Fox,
Michael J. Fox,
Esme Fox,
Schuyler Fox

Michael is an inspiration to the entire world: an actor, an activist, and a survivor. What can one say except, "Thank you, Michael, for everything." His children are beautiful and reflect a certain maturity that is a blessing. Tracy and Michael have their hands full with innocence and beauty. May God bless. —*Joyce*

JIM BELUSHI

Being a dad is
the hardest and best
thing I've ever done.
It kicks ass—
mainly my own.

Fatherhood is
like beekeeping:
the honey is
so sweet, but be
careful of the sting.

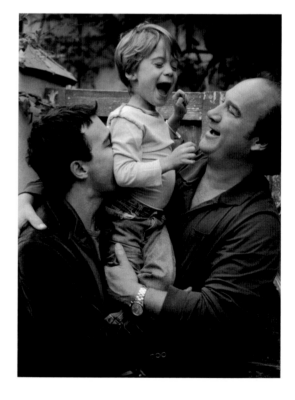

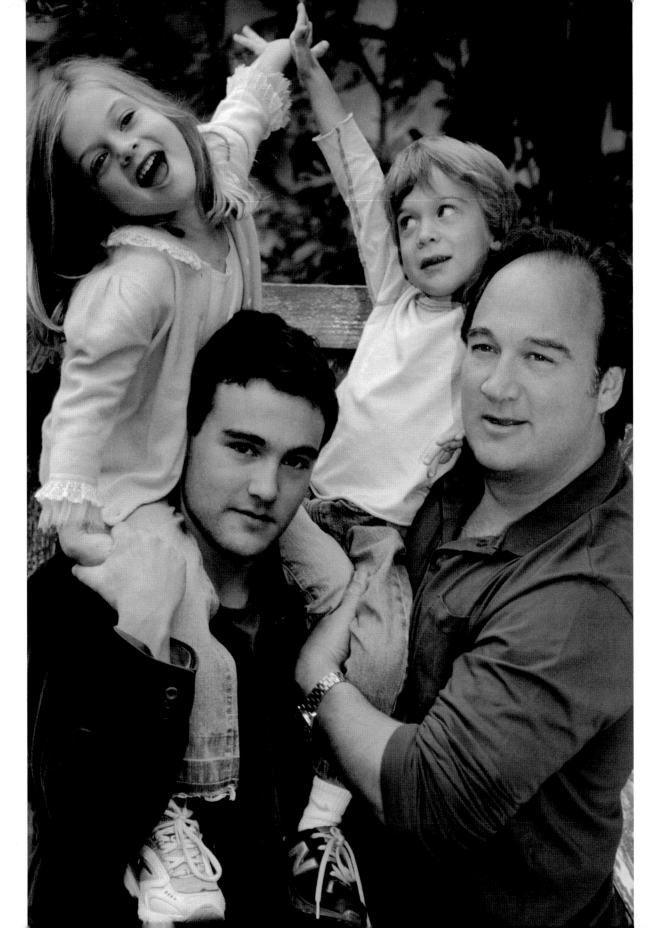

Jamison Belushi,
Robert Belushi,
Jared Belushi,
Jim Belishi

Jim reminded me of my husband:
always ready to go with everything
until his daughter decided she was
finished taking photos before we had
begun. He got mad, then persuaded
her, and ended up bargaining with her:
a daddy with his little girl. There is
certainly never a dull moment. Daddies
really do have a challenging job keeping
everyone in the family happy. —*Joyce*

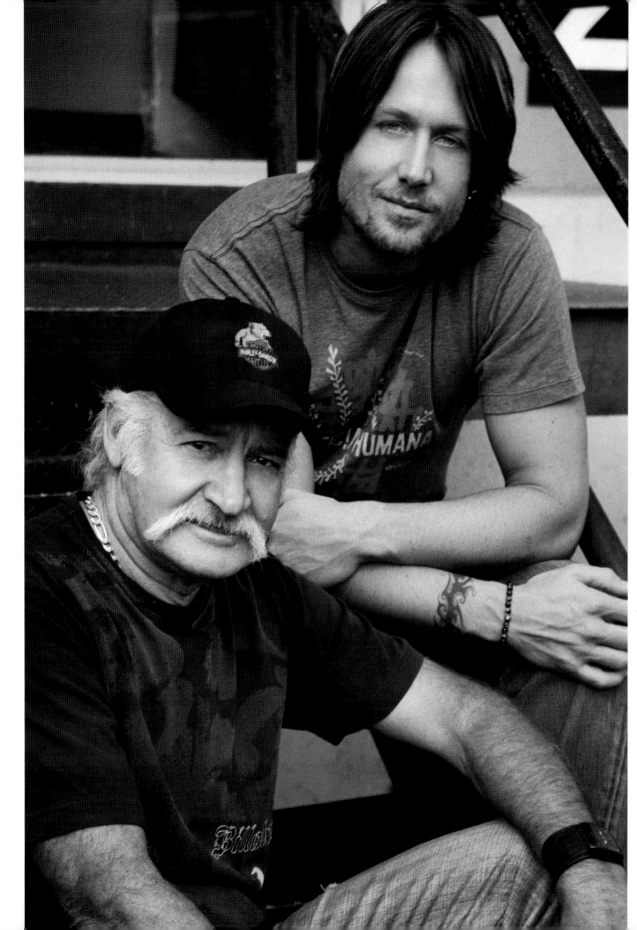

Bob Urban,
Keith Urban

This was a great shoot. I was in New York, looking at colleges with my daughter, when I got the last-minute news that Keith and his father were ready and willing to have their photo taken for the book in Nashville. I jumped on a plane as fast as I could to make this shoot happen. Keith's father was on his way back to Australia and I had theater tickets in New York later that night…I made it! The plane was on time, so was I, and they were ready to go. It was meant to be. Keith could not have been sweeter and more accommodating. For that, I thank you, Keith, and my dear friend, your manager, Gary Borman. —*Joyce*

KEITH URBAN

(with his dad, Bob Urban)

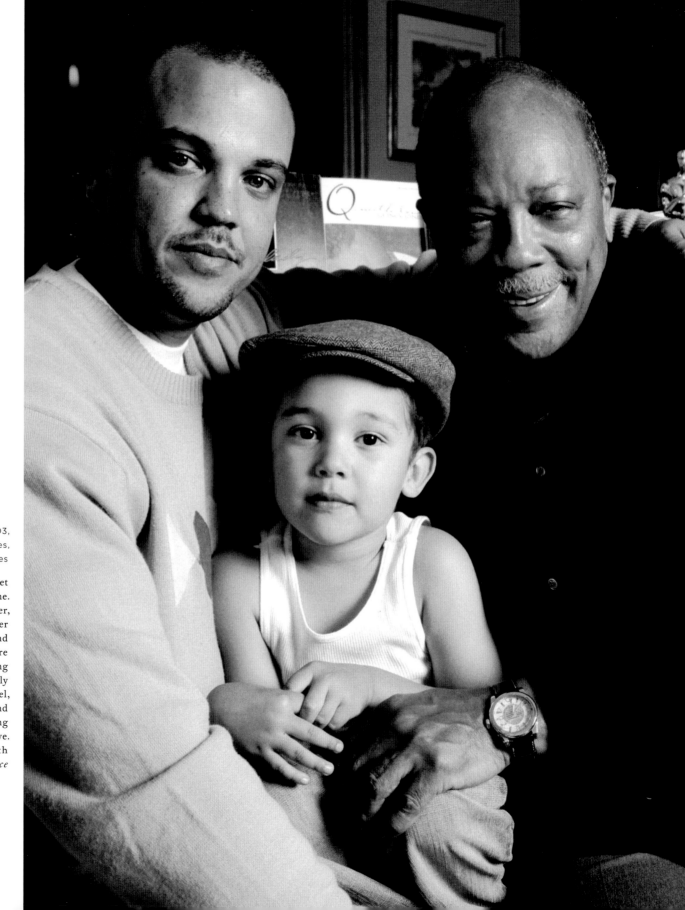

QD3,
Renzo Jones,
Quincy Jones

Monsieur Q. From the day I first met
Quincy until now, he has inspired me.
The musician, the spiritual teacher,
and the politician he is can never
be replaced. The joie de vivre and
the lust for life that he brings are
unfathomable. Quincy is an amazing
father to not only his own family
but to the world. Jolie, Snoopy, Rachel,
Tina, Rashida, Kidada, and Kenya and
all of his grandchildren, including
Renzo, fill Quincy's world with love.
In return, Quincy fills the world with
his love and music. —*Joyce*

QUINCY JONES

Tough love works.
Let your children be a part of the world.
Let the arrow go—
Cut the cord—Travel and be a citizen of the world.
Respect each other's differences
and become a part of another family:
Global Gumbo, which is one world.
Be proud.
Let no external forces define your identity.
Not one drop of your self-worth should depend
on anyone else's acceptance of you.

ANTONIO BANDERAS

Wow, what a charismatic man. Stella, Antonio's daughter, looked up at him with the adoring eyes of a daddy's little girl. Antonio, the Latin icon, was at such ease with everything. I had shot Stella before with her mommy, Melanie Griffith, some years ago. This time she was much more willing—absolutely adorable, then and now. —*Joyce*

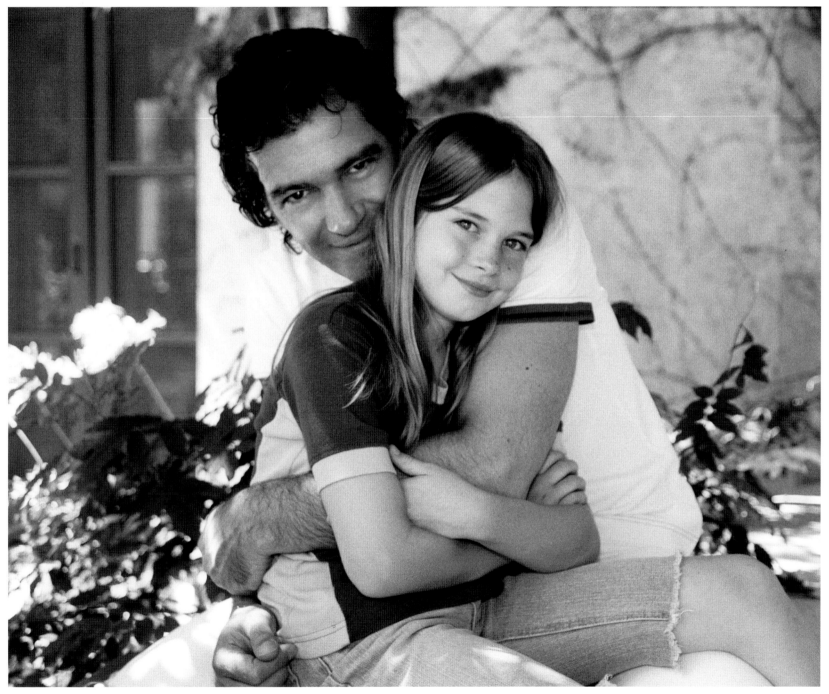

Antonio Banderas, Stella Banderas

The terrifying responsibility of fatherhood is outweighed only by how much freakin' fun it can be.

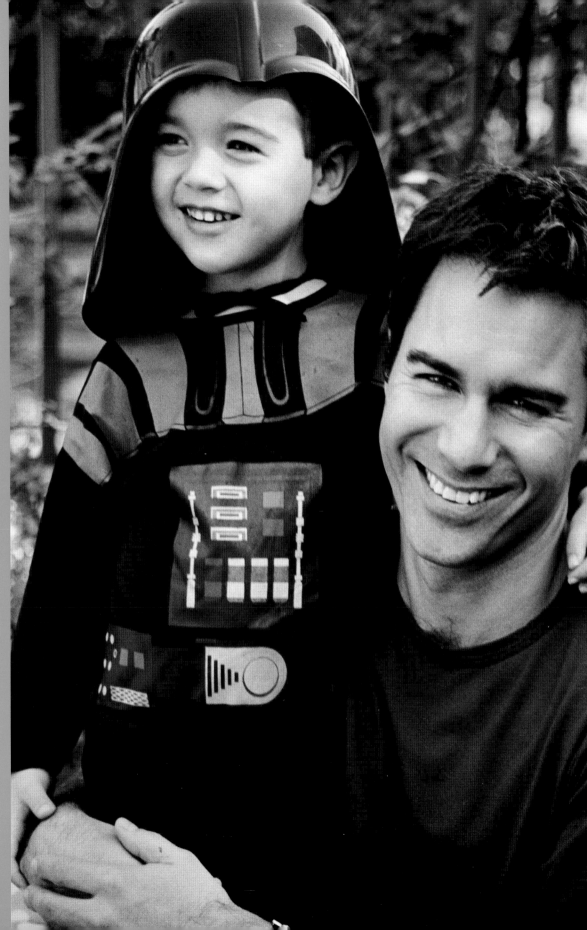

Finnegan McCormack,
Eric McCormack

Like father, like son. That
million-dollar smile! I talked to
Darth Vader the entire time, which
seemed to keep him interested. Being
a typical child in character, Darth
Vader was the favorite of the day.
I wonder how many more characters
he has been since then. Eric seemed
to get a real kick out of his son's
imagination. I am sure imagination
is fostered in that household
as Eric captures so many different
characters' lives so well. —*Joyce*

BEN HARPER

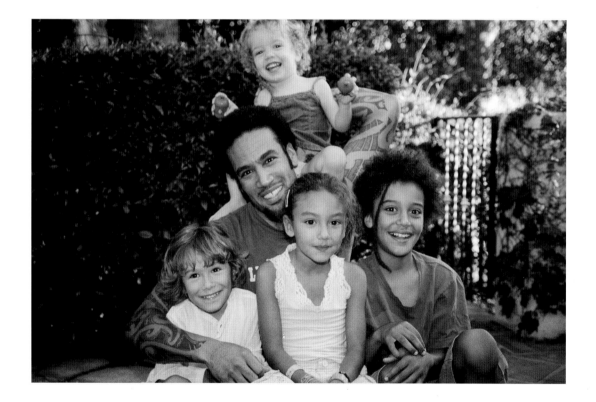

This is a very busy household: as a musician with four little children and actress Laura Dern as his wife, Ben certainly knows the demands of fatherhood. My sense was that Ben was in the thick of child-rearing but enjoying every minute of it. The kids were playful with their daddy and he seemed just like one of them as he was down on the ground, right in the middle of the action. —*Joyce*

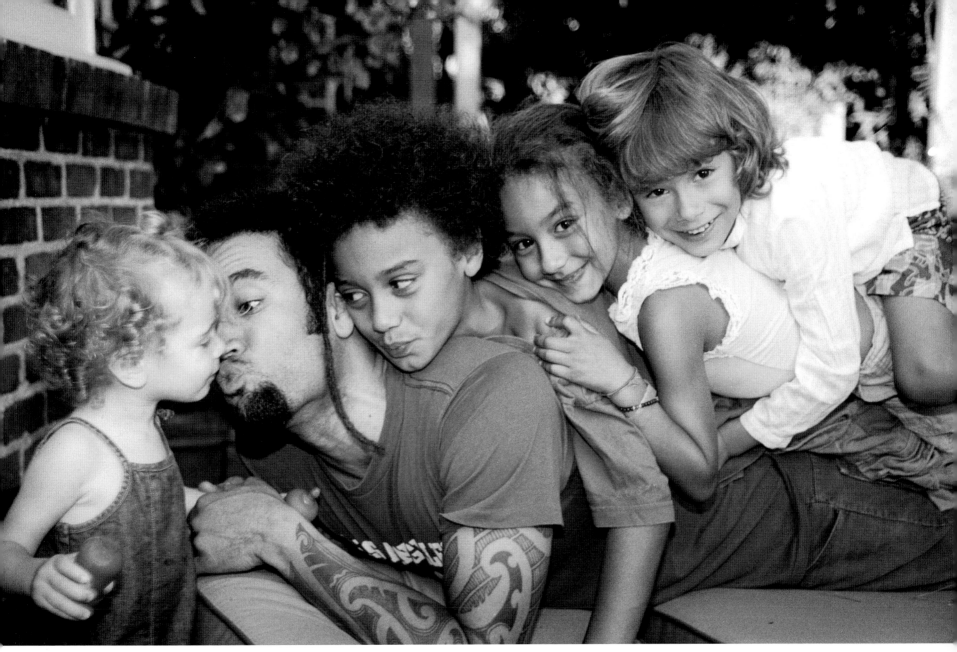

CJ Harper, Ben Harper, Harris Harper, Ellery Harper, Jaya Harper

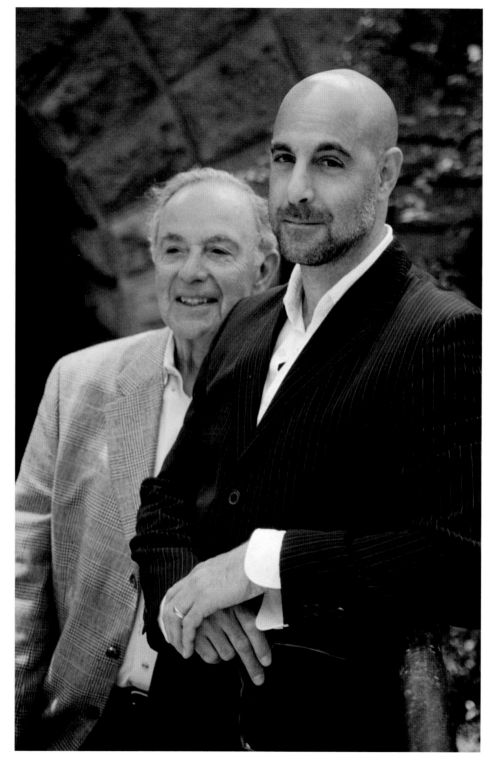

Stanley Tucci Sr.,
Stanley Tucci

I wish I had grown up on Stanleys'—
both junior and senior—block. I felt
so safe and comfortable with the two
of them in the middle of Central Park.
Cool, calm, and collected, as both an
actor and a person, Stanley exudes
all of this and more. His dad was so
proud. It was such a beautiful
afternoon in every way. —*Joyce*

STANLEY TUCCI

(with his dad, Stanley Tucci Sr.)

Expose and introduce your children
to good and wholesome activities.
Encourage them to reach
and strive for realistic goals.
Teach respect for others
and the ideas of others.
Inspire a love of learning.
Encourage creative thought.
Instill the importance of
family and friends.
Spend quality time with your children.
Have faith that your children will
make good choices and
do the right thing.
Set good examples of
behavior, relationships,
and work ethic. *—Stanley Tucci Sr.*

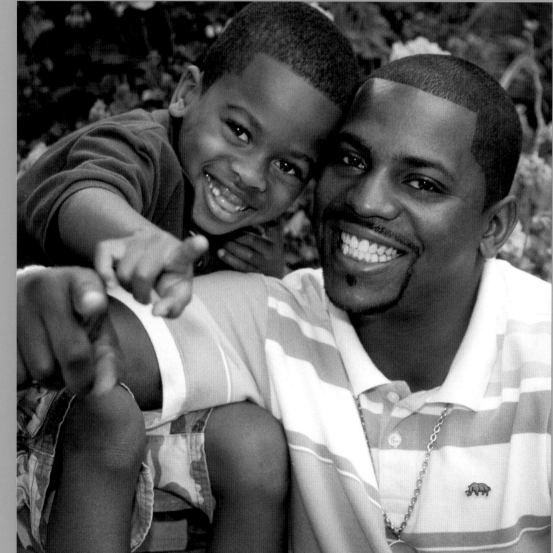

Omikaye Phifer, Mekhi Phifer

I witnessed some of the cutest moments
I have ever seen in my life as I watched
Mekhi and his son, Omikaye, together...
little expressions and feelings about
his dad were uncanny. I will never
forget that adorable little boy sitting
in his daddy's lap smiling and feeling
so proud. What a pair! —*Joyce*

MEKHI PHIFER

When it comes to raising sons, fathers
in my opinion should have a healthy balance
of discipline and nurturing. Discipline is
NOT the enemy of enthusiasm. Boys without
a strong discipline structure tend to get in
more trouble (gangs, jail, etc.) than girls.
Also, leading by example is key! If a son sees
his father not working, disrespecting women,
not exercising nor staying healthy, a lot of
times that negative energy rubs off on the
son and leads to a not-so-productive lifestyle.

Omikaye's mother and I are divorced, so I try
to balance everything in my life as much as
possible. Meaning, since I work a lot and
my schedule isn't a set one, I have to really
put out an effort to spend quality time with
my son because I know he needs his father.
He needs a strong, positive, focused, and
supportive male in his life, and that male is
ME! The great thing is that my ex-wife and
I have a really good relationship, so there
is no set time for me to see or spend time
with my son, which is beautiful because that
breeds an unconscious but very prevalent
aura of respect. Which is not only needed
but also well deserved. The way that his mom
talks to me and about me when I'm present
or not present lets him know that Daddy is to
be respected even though at this stage in his
life he spends more time with her. Because
she speaks highly of me doesn't confuse him
whether or not Daddy loves him and supports
him. And living only four exits away really
makes life good!

KENNY G

Instill in your kids decision-making abilities. Let them make decisions instead of always telling them what to do.

Give them the pros, cons, and consequences and then let them decide. They will learn quickly that the mistakes they make are not something that they will want to repeat! My father gave me the ability to achieve things by not doing them for me, and as an adult I find that I'm very capable of doing anything that I set my mind to. I don't mind making mistakes because it gives me the chance to learn, and that is something I'm passing on to my boys. To me, that is how you show them how much you love them... along with your undivided attention when you are with them and lots of hugs and kisses!!

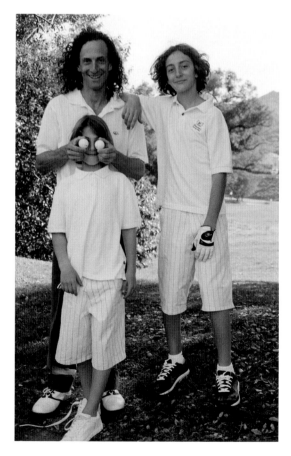

Kenny G seems like a guy who knows exactly what he wants. He loves his family and his music. Kenny's children seemed to go right along with the golf program that Kenny loves so much. It was adorable to see the three of them enjoying themselves on the course. —*Joyce*

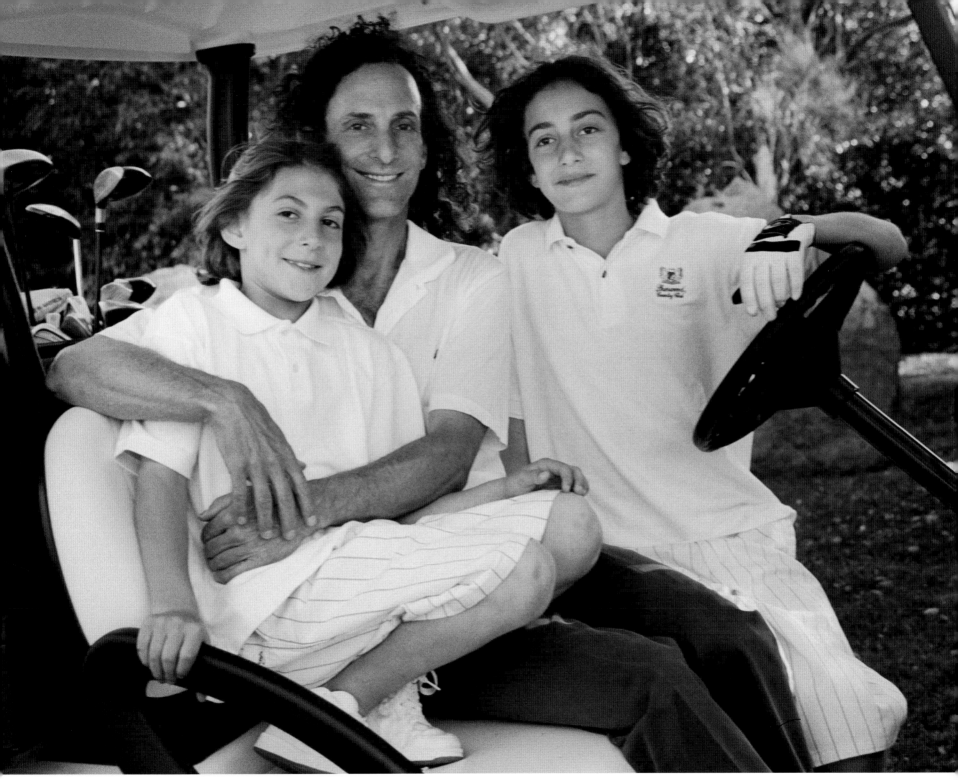

Max Gorelick, Kenny G, Noah Gorelick

ANDY GARCIA

This shoot was great for me. It brought me right back to my roots: Miami, Florida. That is where Andy and his wife are from (in fact, I went to school with her cousin!). Andy seemed like a very well-directed guy who thoroughly enjoys his family. A true family man with a lot to be proud of. —*Joyce*

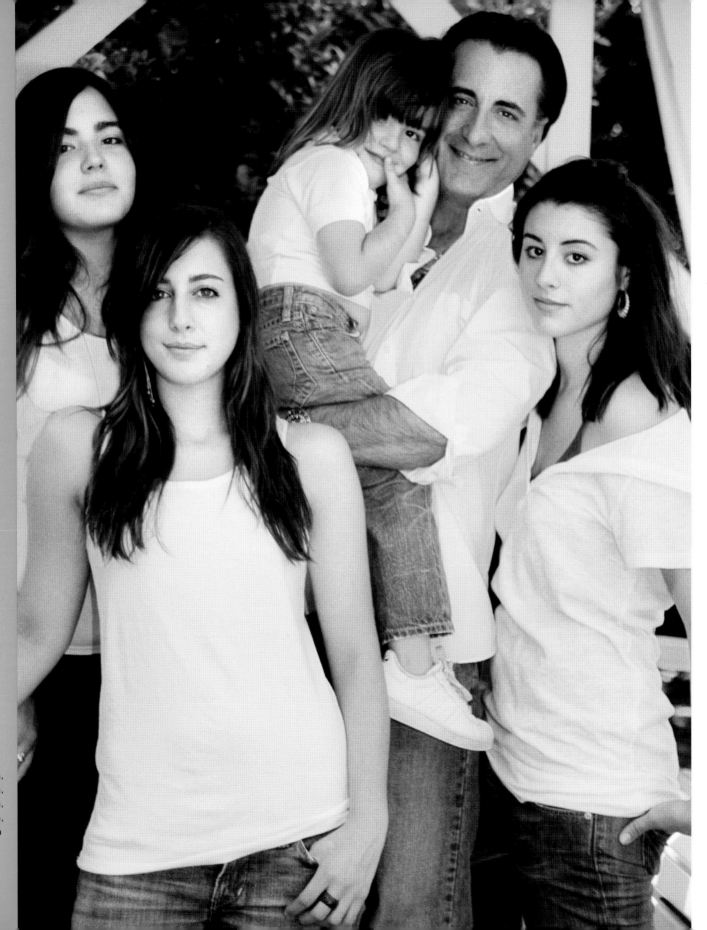

Alessandra Garcia,
Daniella Garcia,
Andres Garcia,
Andy Garcia,
Dominik Garcia

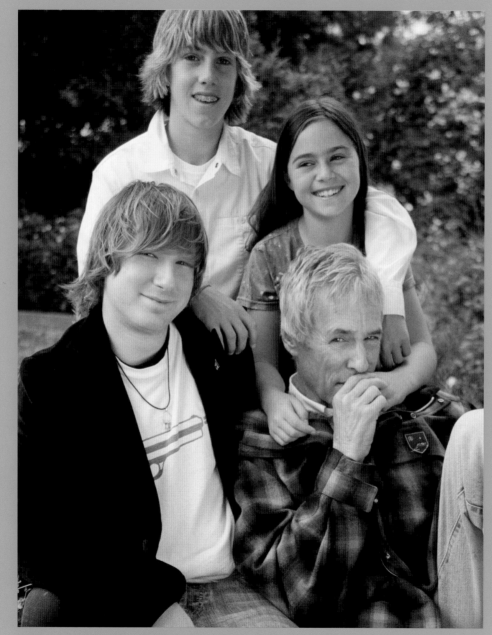

Oliver Bacharach, Cristopher Bacharach, Raleigh Bacharach, Burt Bacharach

BURT BACHARACH

To have young children at this time in my
life is far different than going through the
experience in my thirties or forties. It's much
more loaded with power and a focus and
appreciation of family. So, for me, it completes,
or I must say even outweighs, my music.
I'm grateful for this chance and try to
remember to treasure it every day. I feel
blessed to have this opportunity.

It was a Saturday morning and their
day was just beginning, as the kids
had many sports games to attend.
Burt and his kids seemed incredibly
comfortable with each other. A legend
in the music world, Burt is down-to-
earth and handsome, and his Ralph
Lauren looks have always seemed to
suit him. He truly seemed like the
family man. —*Joyce*

ROBERT WAGNER

Listen to everything your
daughters have to say;
you will find it so enlightening.

What a lucky guy! Surrounded by
three beautiful daughters, he must be
doing something right! They all seemed
so happy to be together, loving their
father, an icon in his own right. He
and his beautiful family certainly look
at home on the ranch. —*Joyce*

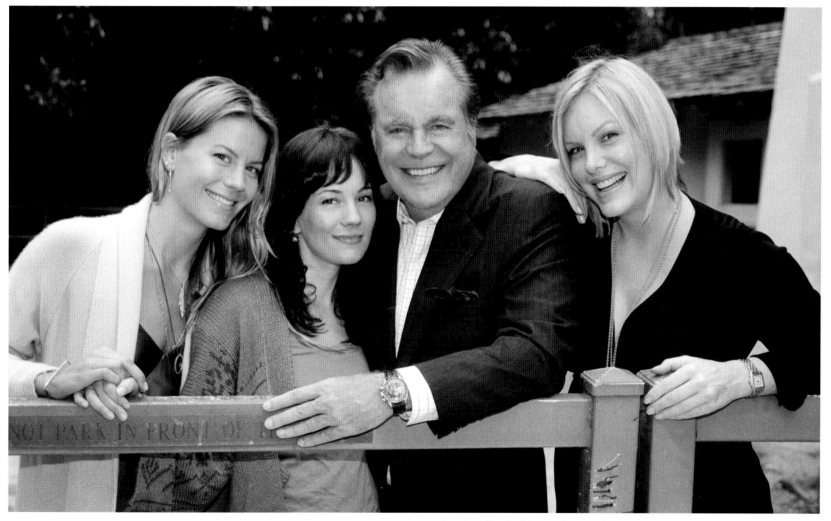

Courtney Brooke Wagner, Natasha Gregson Wagner, Robert Wagner, Katie Wagner

DEEPAK CHOPRA

We work and play together. We challenge each other's assumptions. We treat each other as equals.

Treat your children as you would treat your friends. Don't sermonize. Teach only by example and encourage discussion and encourage questioning.

My father and I were best friends. It was because of him that I was inspired to be a writer and physician. He was a Renaissance man who engaged in many activities, including medical research, acting, writing, and spiritual teaching.

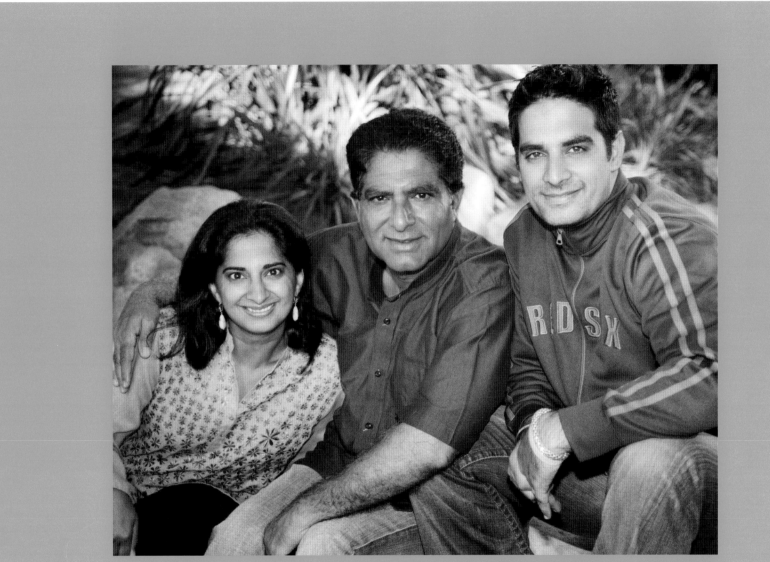

Mallika Chopra, Deepak Chopra, Gotham Chopra

Deepak is an elegant and spiritual man. I was lucky enough to be taught by him to meditate ten years ago when I was first diagnosed with breast cancer. His approach and outlook on life are truly unique. His intellect and soul are one of a kind. His spirituality has been spread among millions of people and has touched everyone's lives. He makes me want to go to India and stay…for a while! He was such a good friend to my mother-in-law, Evelyn, another spiritual being. He was close with her until the very end of her life. —*Joyce*

HUGH HEFNER

In classic Hugh Hefner style, he came out in his robe looking just as I had expected: handsome, debonair, and truly a legend. He and his boys seemed to get a real kick out of each other. The boys surely adore their father, as he adores them. For such an icon, he had such a loving way with his sons. Hef is the utmost professional and was very accommodating throughout the shoot. He certainly made my job easy. —*Joyce*

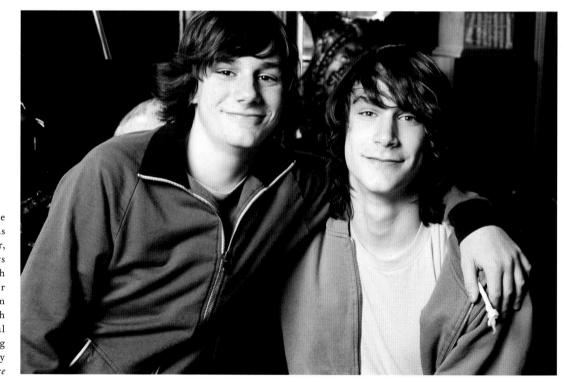

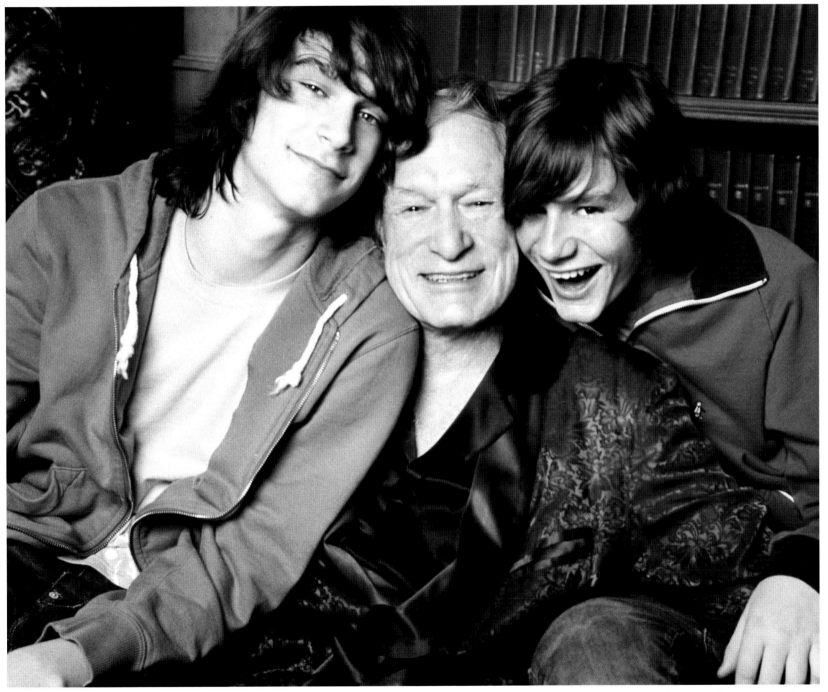

Marston Hefner, Hugh Hefner, Cooper Hefner

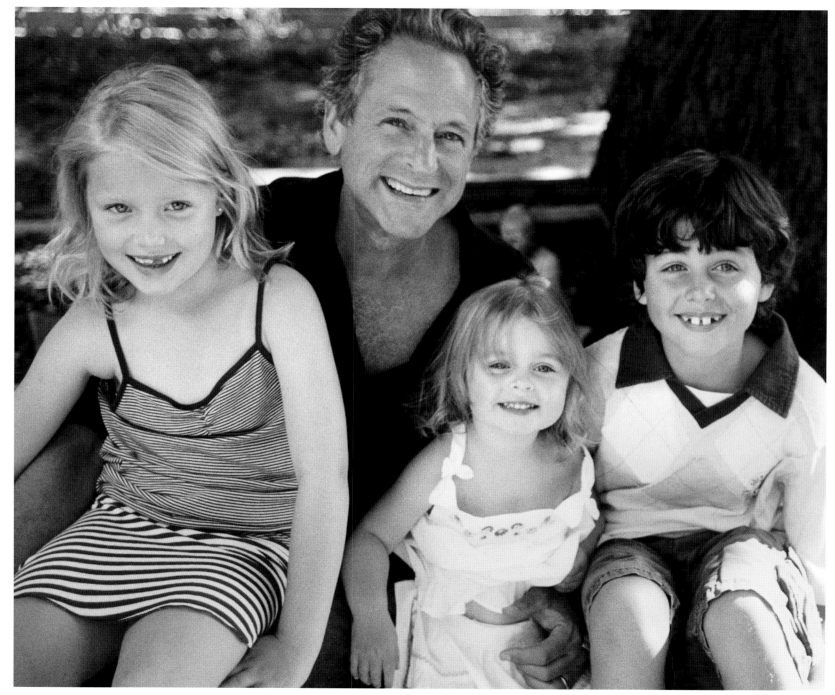

Leelee Buckingham, Lindsey Buckingham, Stella Buckingham, Will Buckingham

LINDSEY BUCKINGHAM

Being a father is a daily learning experience,
not something that can be taught.

When you're growing up, you don't feel
yourself evolving so quickly, but as a parent,
you are continually challenged and reminded
that you cannot keep your children as they
were even a few weeks ago. Being a good
father seems to be about presence, about
balance. The rest follows.

The all-time rock-and-roller. His eyes
are so brilliantly blue with so much
depth. Everything was very mellow
at the Buckingham house when I
arrived. His wife, Kristen, was there
and handed the kids over to Lindsey
with ease. Lindsey seemed to be in
a place of contentment. Although his
music has always reflected various
emotions, whether it is angst or love,
I truly think fatherhood has brought
an inner peace to his life. He seemed
so at peace that day. —*Joyce*

DUSTIN HOFFMAN

Know that your child's job is to successfully
leave the nest and live separate from you,
their parent. This means your job, as a father,
is to give them all the love, support, and
tools they need to do so.

I've tried to be patient, to listen, and to let
my children shape themselves. Ultimately,
I've learned that if I let our home run as a
democracy, I'm eaten alive.

My father passed away many years ago
and I'm still working on our relationship.

When I walked into the Hoffman
house, I wanted to live there. The music
was playing, the children were eating,
and Lisa and Dustin were just soaking
it all in and enjoying their beautiful
family life together. Dustin's smile
is a classic. He is absolutely adorable
and cuddly. An actor everyone has
known, and will always know. The kids
are a product of their environment:
cool, creative, and well assured. There
were a lot of Hoffmans, so the shoot
was challenging. How do I make sure
everyone looks good and keep the
baby happy? With all these different
personalities, everyone gelled so well.
I am very grateful to Lisa, who made
sure that this photo did happen.
Dustin, you are a legend. —*Joyce*

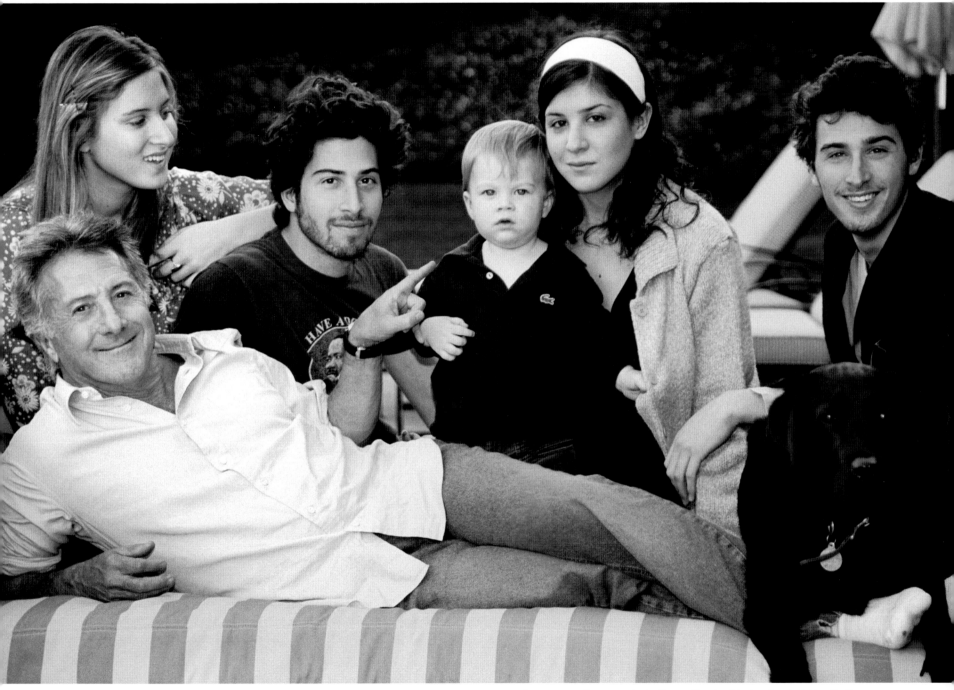

Dustin Hoffman, Ali Hoffman, Jake Hoffman, Gus Culligan, Becky Hoffman, Murphy (black Labrador), Max Hoffman

LENNY KRAVITZ

Being a father gives your
life true purpose and
meaning. All of your senses
and emotions come
into play, demonstrating
God's perfect design.

I didn't know what to expect when everyone told me, "Wow. You got Lenny Kravitz? Mr. Cool!" Mr. Cool and his daughter, Zoe, were both incredibly photogenic and original. He said to me, "Let's just take a walk down the street and you shoot." I felt like I was the paparazzi, except they had consented! They were very calm, collected, and professional. A father and daughter to be admired. Thank you both for being in my book and being so generous. —*Joyce*

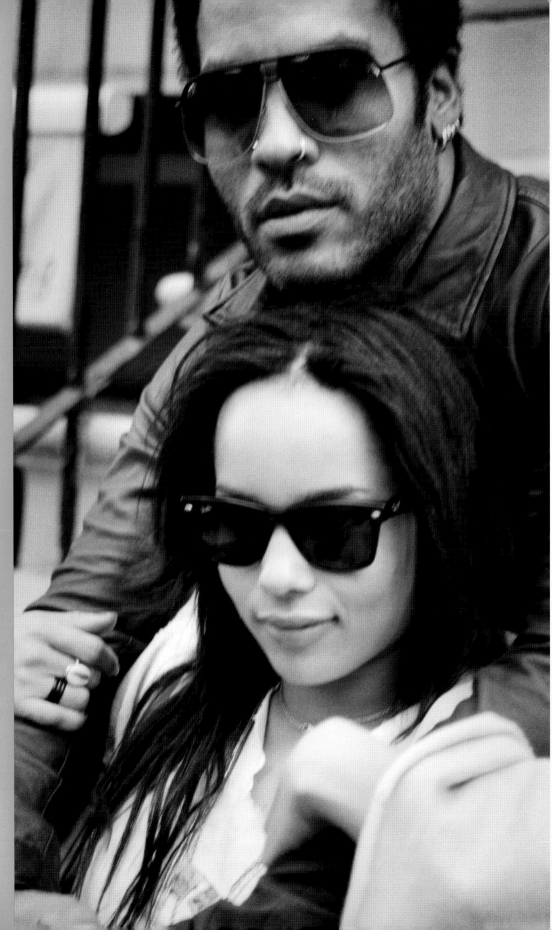

Lenny Kravitz,
Zoe Kravitz

TIM MATHESON

I strive to do rather than say, lead by example rather than preach.

This works better when I focus on being a guiding force and drawing the boundaries than trying to be a friend to my kids. And, at each different age, a different kind of fathering is required. The hard part was knowing when to make the adjustment.

My relationship with my father was difficult. My parents were divorced, and from my mother's perspective, he wasn't a good man. I got a very biased view of him growing up, making it much more difficult to get an objective look at him. We finally bridged the gap later in life, and grew very close. He finally came to live with me when he became sick. I am grateful that we had the time to put aside our resentments, misconceptions, and biases and get extremely close to each other before he died. And, I'm very grateful that he allowed me to take care of him in his time of urgent need.

What a great guy. Tim seems like the all-American great father. His smile could make any child feel good. When Cooper came home from school, Tim was there with open arms and a great big hug for his son. What an ideal way to come home from school. —*Joyce*

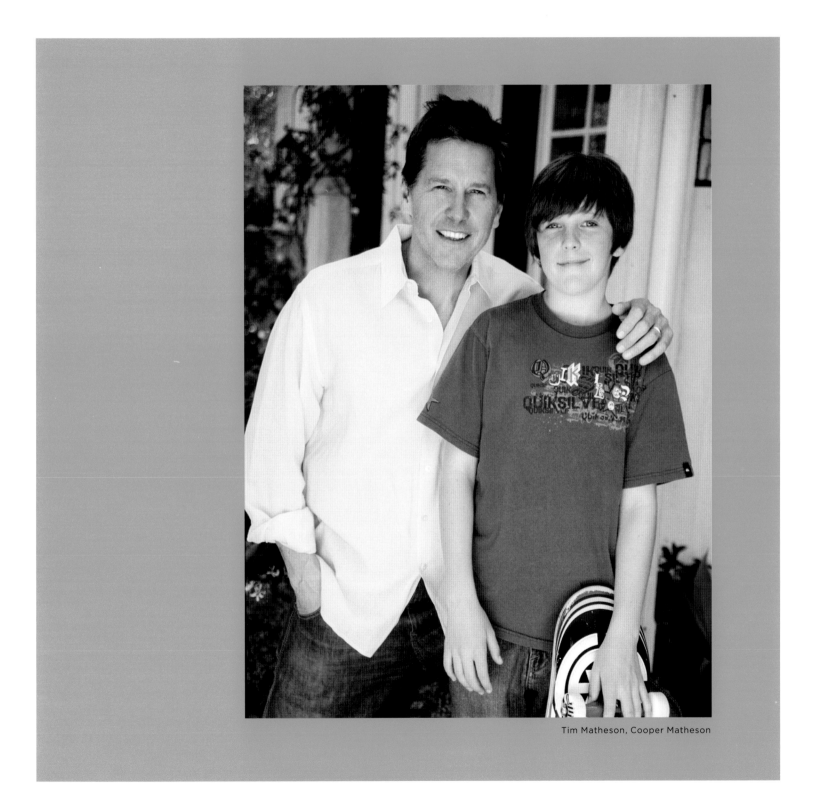

Tim Matheson, Cooper Matheson

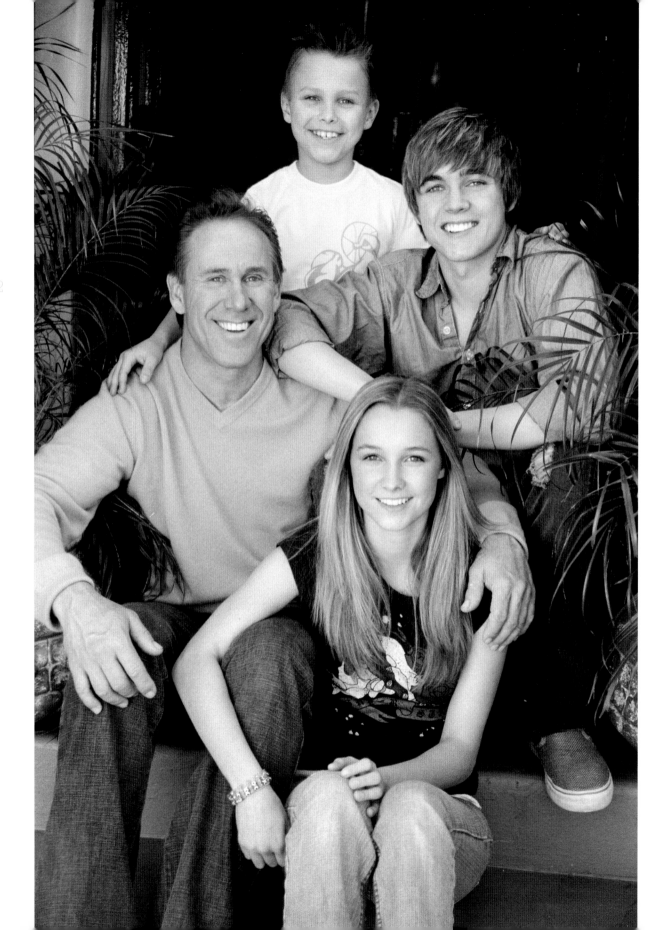

Scot McCartney,
Tim McCartney,
Jesse McCartney,
Lea McCartney

Jesse McCartney, a true teen idol.
He and his family were so wonderful
and willing to be a part of this
project. When I got home from this
shoot, my daughters could not believe
that I had gone without them! He
must have quite an effect on young
teens around the world. For Jesse's
young age, he certainly did not lack
sincerity or humility. What a great
big brother to have! —*Joyce*

JESSE McCARTNEY

(with his dad, Scot McCartney)

There is nothing like being a father! It is a true blessing from God. The love for all of my children has always been unconditional. The joy of watching them take their first step; the sound of their first word; but most important, knowing how much they need you to help them grow into something special.

It is a lot of work being a father . . . but even more work to be a good one.

There is nothing wrong with the word NO! and NO! sometimes does not need an explanation. Tough love hurts. But it works! Every time you see or speak to your children, tell them you love them and give them a big hug and a kiss. —*Scot*

Growing up, my father was an inspiration to me and someone I always looked up to. I always wanted to make him proud. There is a lot of him in me, and as the years go by, I still continue to learn many things from him. We have an unbreakable friendship that I will cherish forever and hope to have with a son of my own someday. His values and his love for family have always been the most important thing, which is what I have learned most from him as a father figure. —*Jesse*

SUGAR RAY LEONARD

Being a dad is the most amazing, emotional, yet bittersweet experience that you could ever imagine! You embrace that bundle of innocent love and know that one day that little face will ask for your car keys!

Sugar Ray Leonard, the smoothest of them all. This man is truly a champion in every sense of the word. His gentle way makes him the true gentleman that he is. Being a champion boxer certainly paved the way for being a champion father. Every time I see him it brings a smile to my face. —*Joyce*

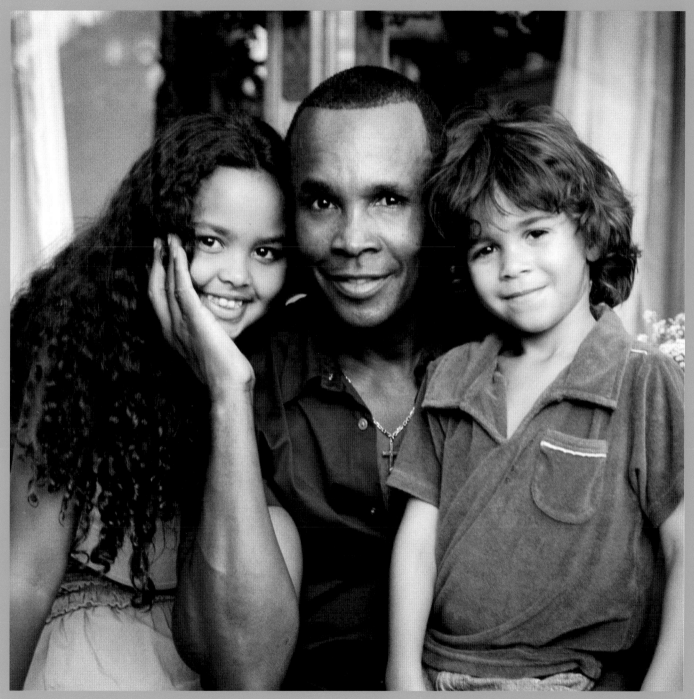

Camille Leonard, Sugar Ray Leonard, Daniel Leonard

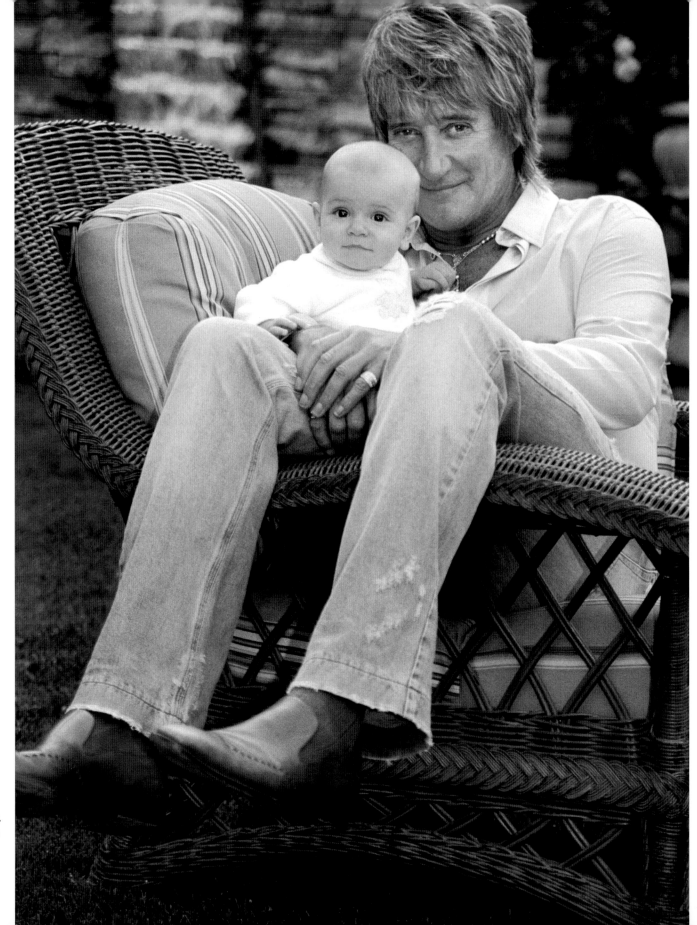

Alastair Wallace Stewart,
Rod Stewart

ROD STEWART

It seems that my parenting skills have improved with experience. I've learned that you've got to just let your children be who they are and celebrate their individuality.

The ultimate rock star. Rod has managed to be on the top of his career for decades. How does he do it? Being a father for so many years has kept him young at heart. His music keeps coming and he never seems to age. When I took this photo with Rod and his youngest son, it brought a smile to my face to see this English rock-and-roller so excited about continuing his role as a father...and legend. —*Joyce*

JON TOGO

(with his dad, Mike Togo)

It's frightening how much I've become my father. It's also reassuring, because there's no one else I'd rather be like. *—Jon*

A father's job is to love his child. *—Mike*

Jon and his dad were such a delight. The true New Englanders were so appreciative of my taking their photo for this book. They had no idea how appreciative I was that Jon had agreed to participate and sincerely wanted to be in my book and help. Jon is absolutely adorable, with a little-boy way about him, and his dad is very similar. They were a real pleasure to get to know. Thank you, Togos, for your ongoing efforts to help me finish this book. *—Joyce*

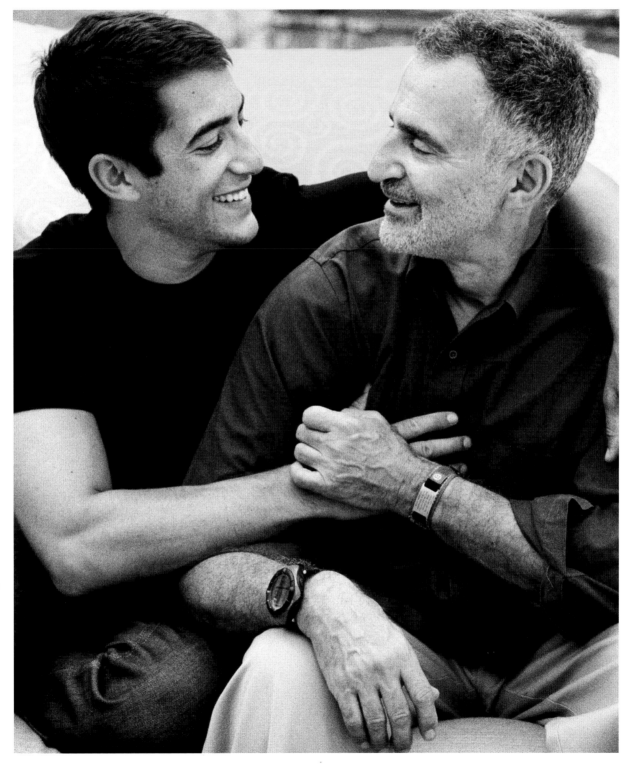

Jon Togo,
Mike Togo

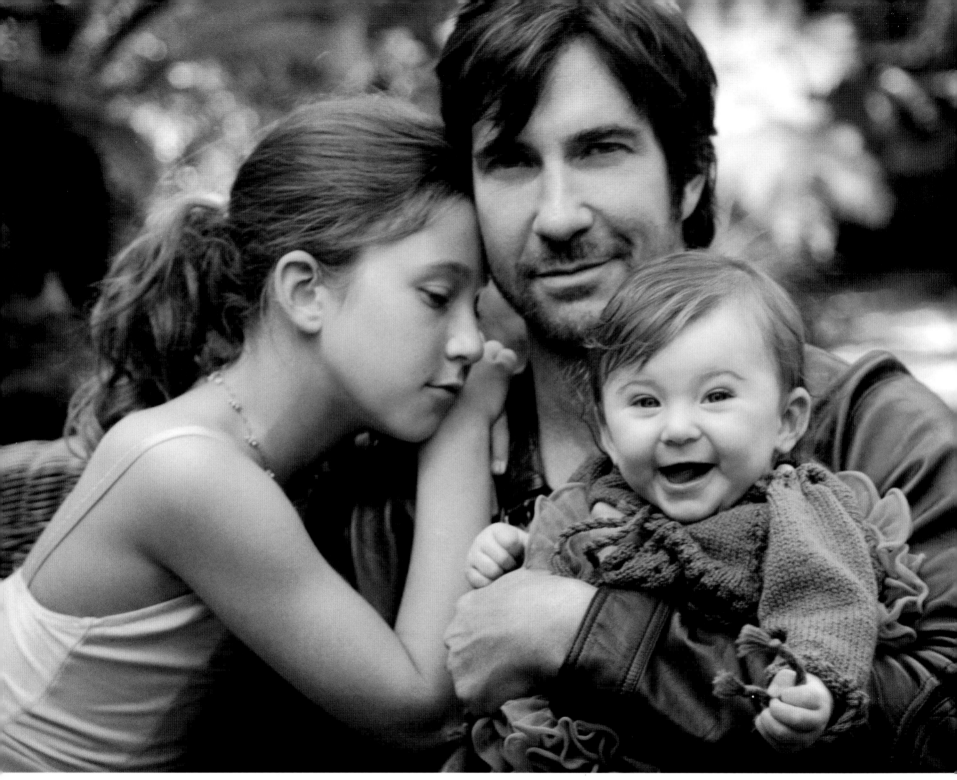

Colette Blu McDermott, Dylan McDermott, Charlotte Rumi Rose McDermott

DYLAN McDERMOTT

I only understood what love was when I became a dad to Colette and Charlotte.

My advice: let your kids know they are the Picassos and Mozarts of the new world.

Dylan and his wife, Shiva, have always been incredibly supportive of my charity and me. Dylan has a very charismatic and caring way with his children that he exudes in this photograph. His adoring eyes could make any child feel comfortable, especially his own. His love for his family is so obvious. —*Joyce*

ERIC IDLE

What a talent. Ever since his Monty Python roles, Eric has had so many people laughing for so many years. One of the nicest things I have heard a father say was when Eric thanked his daughter after the shoot for letting him be in a photo with her. What an adoring father and husband. Thank you, Eric, for always keeping the world laughing. —*Joyce*

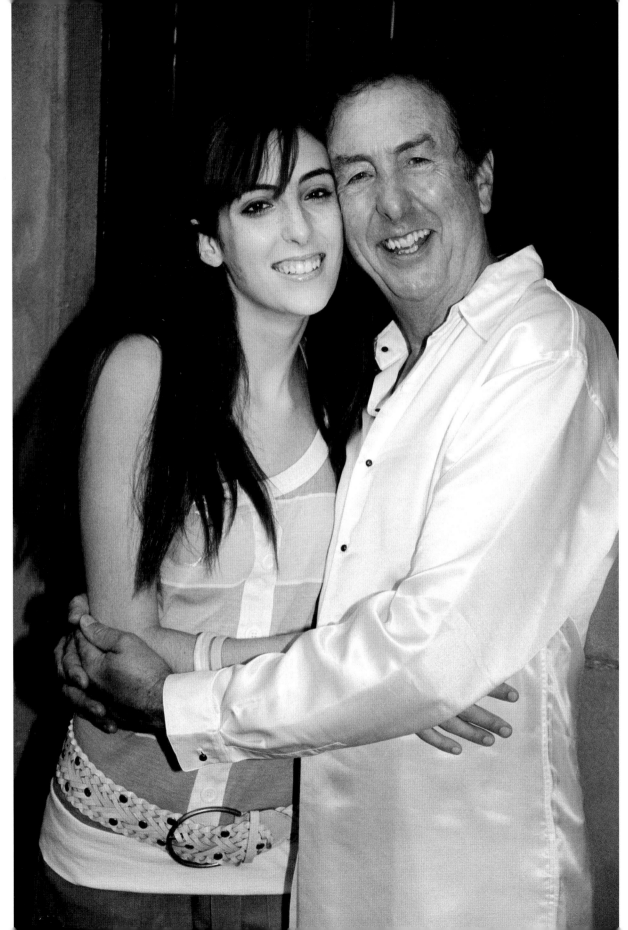

Lily Idle,
Eric Idle

KIEFER SUTHERLAND

Fatherhood has been
the greatest challenge
of my life, and
the most rewarding.

What a cool dude. Kiefer could not
have been more gracious to me when
I arrived at his home to take this
photograph. Kiefer's adorable smile
and twinkle in his eyes were so
natural and relaxed as I looked at him
through the camera lens. I left
that shoot feeling how lucky I was
to be able to take these photos of
Kiefer and his kids. What a groovy
and talented guy. —*Joyce*

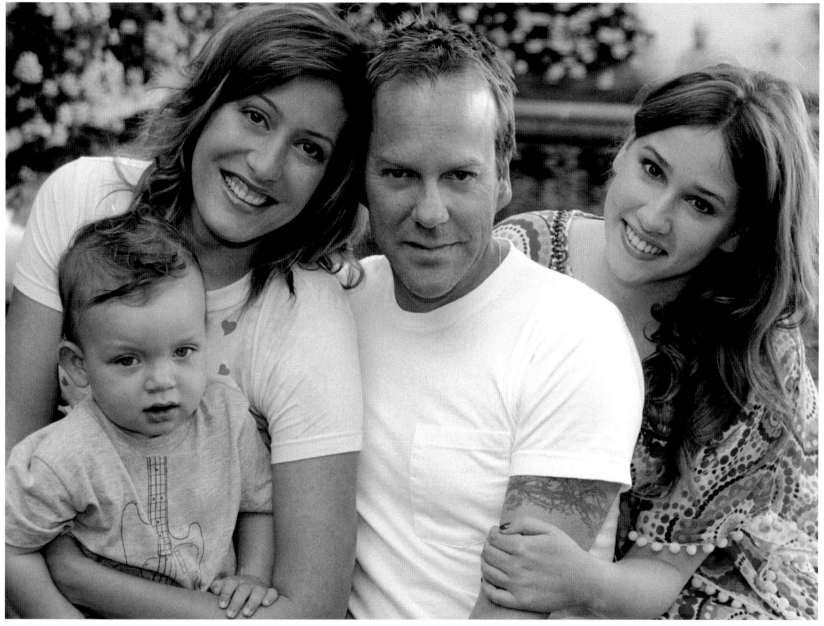

Hamish Terry Russell Kiefer Sinclair, Michelle Kath-Sinclair, Kiefer Sutherland, Sarah Sutherland

JIMMY CONNORS

Jimmy is adorable and such a nice man. Can you imagine living with that much pressure in your life? Being a world-class tennis champion and staying so calm and collected—truly a marvel. A true pro at every level. What a great role model. Jimmy's children really respect him. The nicest and warmest people one could ever meet. —*Joyce*

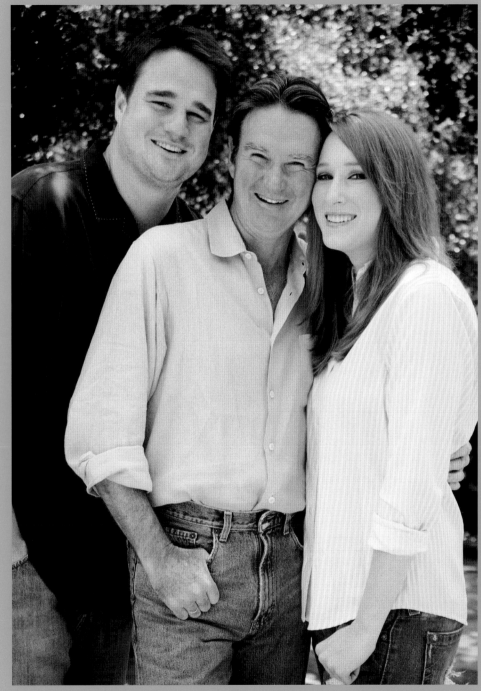

Brett Connors
Jimmy Connors
Aubree Connors

FLEA

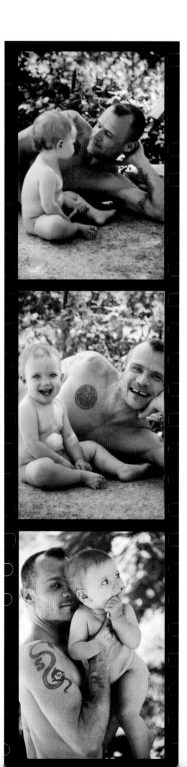

Flea was on the road with the Red Hot Chili Peppers but, luckily for me, was home on the day when I happened to call him. He told me to come over in 45 minutes to do the shoot. For a busy musician home for one day during a tour, Flea was so generous to allow me to come over. What a giving man. His little baby was fast asleep and when she woke up she was full of smiles. Her big blue eyes and sweet smile make her the perfect combination of her mommy and daddy. Again, I want to thank you, Flea, for being so amenable during a busy time of your summer touring. —*Joyce*

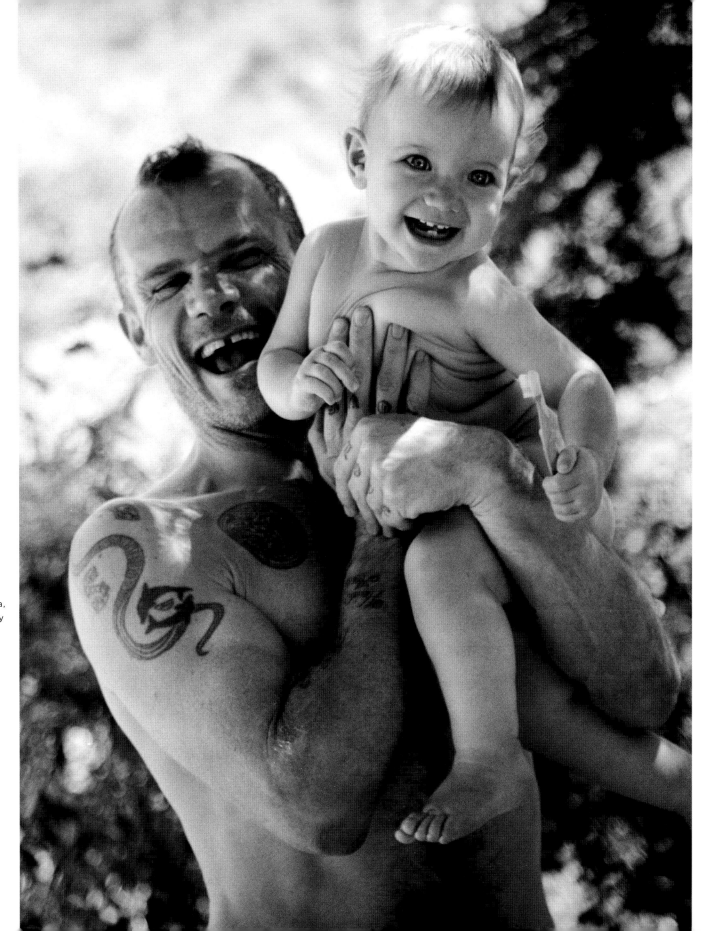

Flea,
Sunny

SIDNEY POITIER

My six darling daughters and my wonderful
wife allow my views on matters such as
gender sensibilities a fair and honest hearing.
Then we vote. And I lose. Again. By a score
of seven to one. Oh well! And so it goes.

Sidney P., the definition of elegance.
A courageous man who has paved the
way for all of us. He has taught us
that with a belief in yourself,
hard work, and aspirations, life can
be a dream. Sidney's presence and
eloquence have blessed us all. His words
of wisdom are eternal and will be a
part of our lives forever. Having six
beautiful daughters must certainly
be a challenge for any father, including
Sidney. However, he approaches this
job with ease. They fill his life with
a real joy and contentment. What
lucky girls to be his protégées! —*Joyce*

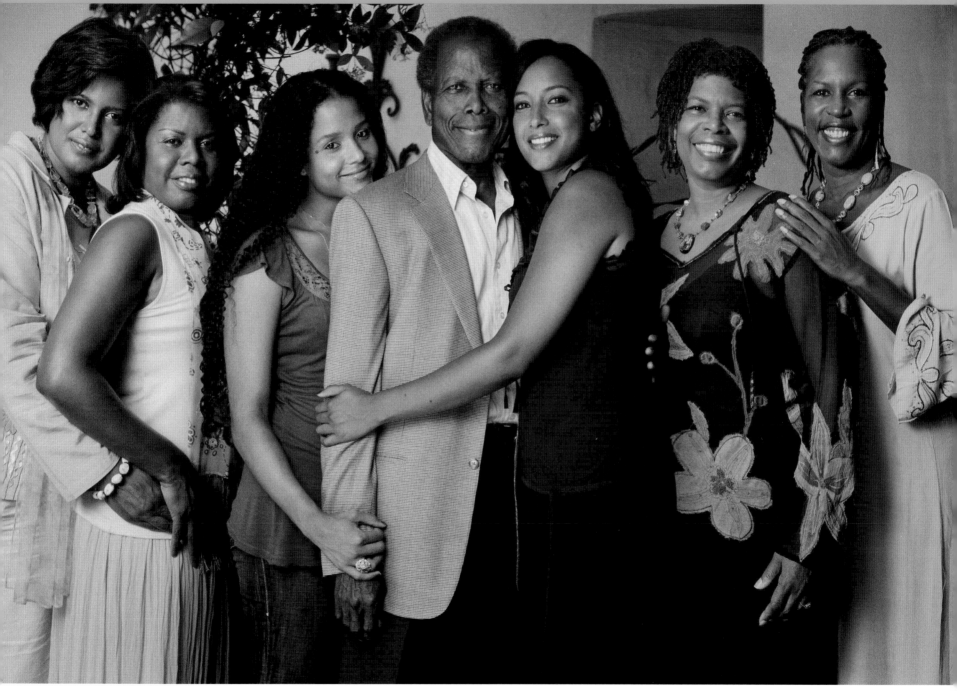

Gina Gouraige, Sherri Poitier, Sydney Poitier, Sidney Poitier, Anika Poitier, Beverly Henderson, Pamela Poitier

GENE SIMMONS

I never wanted to get married!!! And,
as embarrassed as I am to admit it,
I never wanted kids!!!

And then I met Shannon Tweed. At the
Playboy Mansion, of all places. Here, finally . . .
was the woman of my dreams.

Shannon and I have been together 23 years,
happily UNmarried (still worried about that one)
with a 17-year-old son and a 14-year-old
daughter. And, if God had ever intended to
have a sense of humor, I am living proof of that.

Now all I ever worry about is Shannon and
our two midgets (as we lovingly call them) . . .
and going out to work to bring home the bacon
for the family I love.

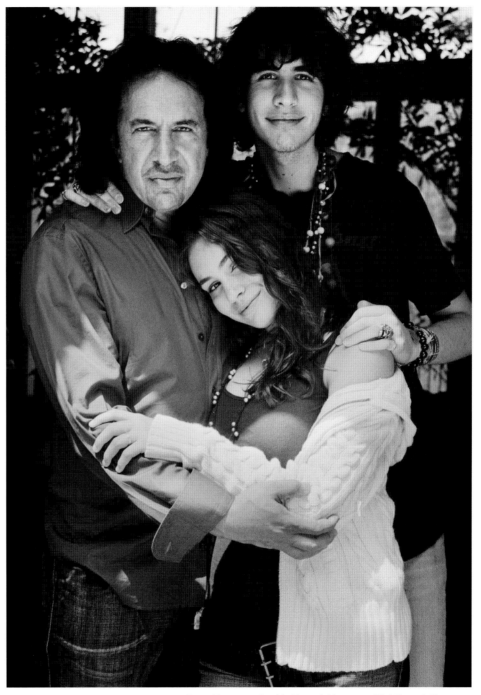

Going to the Simmonses' house was like entering the KISS hall of fame. This man has a lot of history to share and so I was not surprised when I arrived to discover that they were in the midst of shooting yet another reality show, this time centered around the Simmons family. Even though Gene is quite a busy man, he definitely let me know that he is a hands-on father. —*Joyce*

Gene Simmons, Sophie Tweed-Simmons, Nick Tweed-Simmons

CARL AND ROB REINER

Carl and Rob were one of my first shoots for this book. Their family reminded me of my own, three kids who did not necessarily want to sit for a photo session. Rob and his dad, Carl, having had so much experience both behind and in front of the camera, were very forgiving and fun. It was beautiful to see all three generations interacting so lovingly in the midst of the busy Reiner family. —*Joyce*

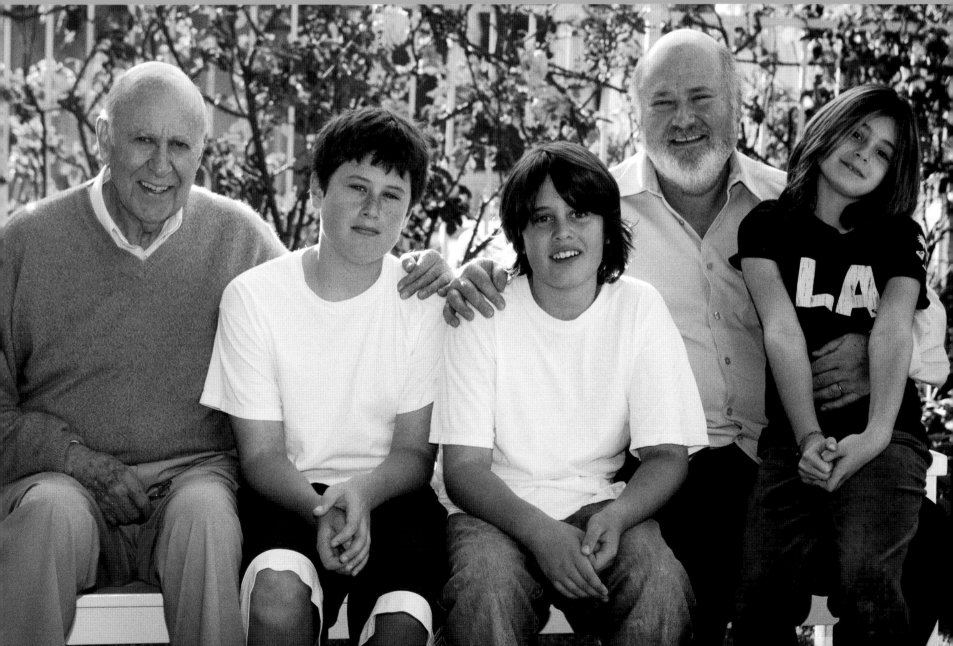

ADAM BRODY

(with his dad, Mark Brody)

As a parent, you like to think you know what is best for your children. After all, you have had the benefit of time and experience that they have not had, and certainly that should count for something. But I have learned through Adam and my other children that what I envision as best for them is not necessarily what they want or what they need. They have taught me to keep an open mind and to let them follow their own unique interests and passions. One of the greatest pleasures in my life is to see Adam succeed at something he is passionate about. I have learned a lot from each of my kids. Lessons and experiences that will always be with me. —*Mark*

What a sweetheart! For such a young man, Adam was certainly ready and willing to help with a worthy cause. When asked to participate, he did not hesitate. The whole family was there and they were all such lovely people and so proud of their son... with good reason. Adam is absolutely adorable. —*Joyce*

Mark Brody, Adam Brody

CHRISTIAN SLATER

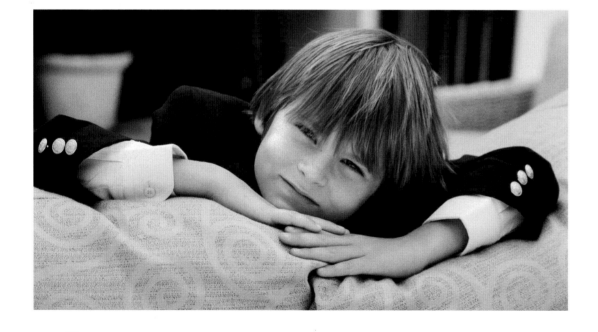

I admit this was a second shoot! This was my only re-do for the book because the first shoot was a little hairy. Christian brought his two beautiful children and his little dog. Unfortunately, I have a big dog who wouldn't behave! I had to hold my dog and try to take the photos all at once. It was all a little too blurry...literally. Christian, being the nice guy that he is, was willing to try again. As you can see, I am so glad I got this photo. He and his kids couldn't be more adorable, and boy, do his kids love their daddy! —*Joyce*

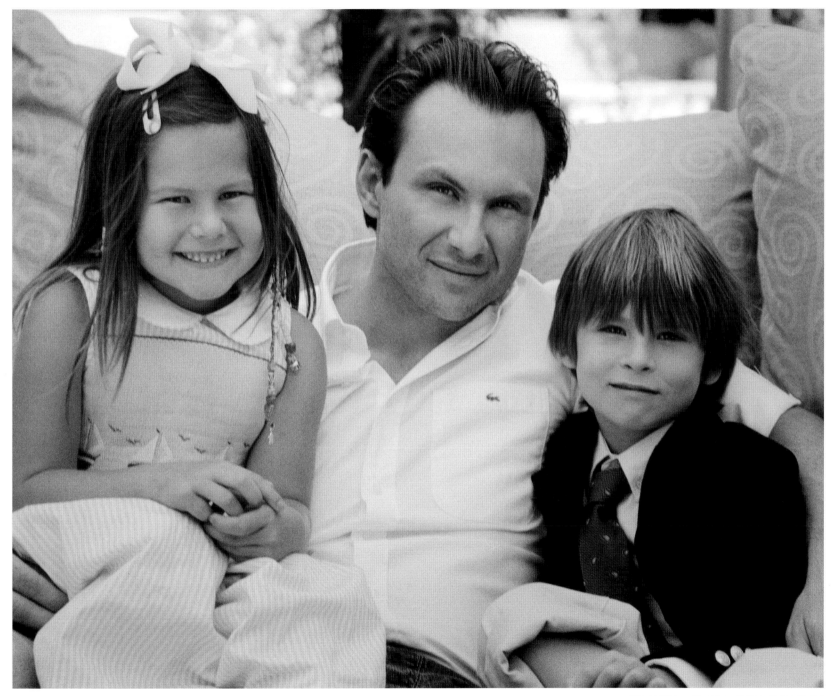

Eliana Slater, Christian Slater, Jaden Slater

ED RUSCHA

I was so honored to go to Ed's studio to meet him and his son and grandson. The paints, the canvases, all of his materials that he uses to create these masterpieces, just sitting around, along with some of his paintings…I was in awe. Not to mention that Eddie, being an artist in his own right, and his father had the ultimate respect for one another. They had such a congenial way about them, I could tell that they really love what they do and how they do it. I could see by Ed and Eddie's faces that they got such a kick out of Milo. He certainly was quite the "cool" kid with both a father and grandfather as great artists. May the lineage continue! —*Joyce*

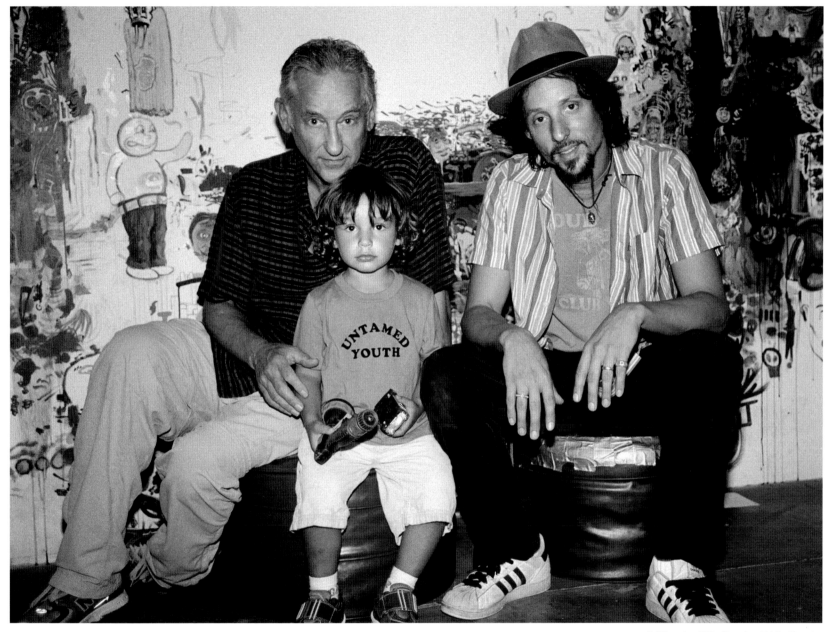

Ed Ruscha, Milo Ruscha, Eddie Ruscha

ACKNOWLEDGMENTS

I could not have made this book alone. I am forever thankful to:

Irving Fell, the wonderful daddy who taught me everything I know. Thank you for being a great father.

Irene Fell, my mommy who I love and miss so much. You gave me the inner strength and courage that I have today.

Michael, my other half. I will always remember how loving and caring you are to me during both the extraordinary and the darkest days of our lives. I am forever grateful.

Anika, Leyla, and Annabelle, my three gems. You are all so blessed to have such a caring and loving father. Always live, love, and laugh.

Evelyn Ostin, the most special woman in the world to me. I will always love you and will forever think about our lives together. Evelyn, you taught me so much in my lifetime. There is not a day that goes by that I don't think of you. Thank you for everything.

Mo Ostin, the all-time cool father, father-in-law, and Papa. May your strength and spirit stay strong as we continue our lives together.

Robin Fell, my loving sister. We will always be bonded together by our hearts.

Randy Ostin, my brother-in-law. Keep us smiling, RanDooch! We all love you.

Paul Reiser, for one word a day, it only took you 2500 days! Once again, your sense of humor and sensitivity on the topic of fatherhood has been proven to both make us laugh and warm our hearts. Your gift for words is extraordinary. I will always remember how hard you made Evelyn laugh on those Tuesday nights. I am forever grateful to you and Paula for our friendship, and am grateful to the Laskers for making the introduction!

Cindy Gold, I never could have made this book without you. I treasure your friendship and talents. May God bless you and your family.

Caryn Greenhut, for being a huge part of my life. You are a very special person with multiple talents and roles. You are my surrogate daughter. You are Anika, Leyla, and Annabelle's surrogate mother. And most of all, you are our best friend.

Jeri Heiden, we did it again! I am so lucky to have such a talented art director to make me look good! Thank you for your availability, your commitment, and your amazing creative eye.

Suzanne Gluck and Andy McNicol, for your endless support and belief in this project.

Kate Prouty, for making my second publishing experience as great as the first!

I want to again thank all of the participants in this book for their time and efforts. I am incredibly grateful that you gave me the opportunity to make this book a reality.

An extended thank you to:

Karl Ackermann, Merv Adelson, Rosanna Arquette, Gelila Assefa, Ali Azoff, Bob and Dori Bardavid, Robin Baum, Jennifer Belushi, Dr. Jim Blechman, Maggie Boone, Gary Borman, Kristen Buckingham, Colleen Camp, Kate Capshaw, Sophia Chang, Rita Chopra, Jude Cole, JoAnne Colonna, Sara Cumings, Vahe D'Ala, Clare Davis, Allison Diamond, BJ Dockweiler, Carleen Donovan, Andrea Feldstein, Wendy Finerman, Ivo Fischer, Debbie Ford, Debborah Foreman, Gil Friesen, Craig Fruin, Lindy G., Marivi Lorido Garcia, Gary and Maria Gersh, Diana Gettinger, Katie Gottesman, Melanie Griffith, Peggy Haig-Kim, Jackie Hamada, Jane Hansen, Kimberly Hefner, Lisa Hoffman, Janet Holden, Eliza Hutton, Gloria Jones, Harvey and Nina Karp, Dr. Soram Khalsa, Michael and Jena King, Tania Kosevich, Penny Lancaster, Diane Lane, Fran and John Lasker, Barbara Lazaroff, Justine Leguizamo, Richard Leher, Bernadette Leonard, Téa Leoni, Michael LoSasso, Lori Loughlin, Dena Luciano, Kristie Macosko, Molly Madden, Sue Main, Maurice and Nathalie Marciano, Ashlee Margolis, Megan Murphy Matheson, Ginger McCartney, Patty McGuire, Chris McMillan, Kelly Meyer, Demi Moore, Michelle Moran, Jerry and Annie Moss, Nardulli Photo Lab, Elizabeth Nye, Kristi Odom, Sharon Osbourne, Lynn and Jeri Ostrow, Cynthia Pett-Dante, Joanna Poitier, Tracy Pollan, Marci Poole, Carolyn Rangel, Gabrielle Reece, Michelle Reiner, Hunter Reinking, Shiva Rose, Paula Reiser, Nanci Ryder, Leon Schillo, Michele Singer, Dr. Dennis Slamon, Ryan Slater, Afton Smith, Kathy Smith, Rebecca Erwin Spencer Arnold Steifel, Gary Stiffelman, Barbra Streisand, Nick and Kelly Styne, Kelly Sutherland, Frances Tamaariki, Jackie Tipper, Jon Togo, Kate Tucci, Shannon Tweed, Tom Voltin, Lily Waronker, Margaret Weitzman, Marsha Williams, Rita Wilson, Stacy Winkler, Claudia Wong, Rabbi Eitan Yardeni, Laura Ziskin